RIDGEFIELD
CHRONICLES

—

RIDGEFIELD
CHRONICLES

JACK SANDERS

THE
History
PRESS

Published by The History Press
Charleston, SC 29403
www.historypress.net

Copyright © 2014 by Jack Sanders
All rights reserved

First published 2014

Manufactured in the United States

ISBN 978.1.62619.700.8

Library of Congress CIP data applied for.

With many thanks to Sally for all her help and support; to Karl, Betty Grace and Thomas Nash of the Ridgefield Press for their inspiration and encouragement; and to all the many people who have contributed information that has led to this book.

CONTENTS

INTRODUCTION

Every community is special with its own history, personality and local characters, but I like to think that, in many ways, Ridgefield, Connecticut, is especially special. After all, how many towns of its size have had six Pulitzer Prize winners as residents? How many have had a half dozen of its people featured on United States postage stamps?

And how many have issued medals honoring the nation's most notorious traitor?

Ridgefield has been home to many artists and writers, soldiers and sailors, business and finance titans—as well as a few notable criminals and plenty of otherwise interesting people. First inhabited by American Indians, the town was settled starting in 1708 by farmers whose roots were in England and Holland. A century and a half later, the community was discovered by wealthy New Yorkers seeking a refuge from the city, and with them came the Irish, the Germans and the Italians, who worked on their estates and provided other support services. And last came the commuters; a town that started out agrarian and became a resort has now turned into a suburban community, known for feeding both mind and body with excellent schools, centers of the arts and fine restaurants.

Ridgefield Chronicles is not meant to be a formal history of the community but rather glimpses into aspects of Ridgefield that will give its residents and visitors a better understanding of this unusual town. As a newspaper editor covering the community, I long ago became interested in the people, places and things that have made up Ridgefield. For this book,

I have tried to collect aspects about the town's history that are not only interesting but also reflect the diversity of Ridgefield's people and the things they accomplished and the way they lived. The book also examines the town's varied geography and the names local people have attached to it over the years.

Much of this information has not appeared in the town's three formal histories or in the dozen or so other books that have been written about aspects of the community's past. Sources include the pages of the *Ridgefield Press* and other periodicals and books, interviews with scores of old-timers, thousands of deeds and other documents filed in the town hall and even the gravestones in the town's cemeteries (which might be viewed as outdoor history books).

Ridgefield Chronicles includes writing I've done over the past forty years, both for the *Ridgefield Press* and for my website, RidgefieldHistory.com, or blog, naturegeezer.blogspot.com. Those pieces have been modified and updated for this volume.

HOME OF THE BRAVE AND TALENTED

Ridgefield has been a home to the famous and the infamous, the rich and the poor, the honored and dishonored. Here is a look at some of the town's more noted and accomplished residents.

THE PHILATELICALLY FAMOUS

A surprising number of Ridgefielders have been honored on United States postage stamps.

Perhaps the most famous was Eugene O'Neill, the Nobel Prize–winning playwright who lived on North Salem Road in the 1920s. The postal service issued a one-dollar stamp bearing his image in 1973, twenty years after his death, as part of the Prominent Americans series.

In 1995, the postal service produced a seventy-eight-cent stamp, honoring suffragist Alice Paul, in its Great Americans series. Ms. Paul, who spent her life fighting for passage of the Equal Rights Amendment, had a house on Branchville Road and later lived at Altnacraig, a nursing home on High Ridge. Appropriately, the stamp was designed by Chris Calle, a Ridgefielder who has created the art for many United States postage stamps.

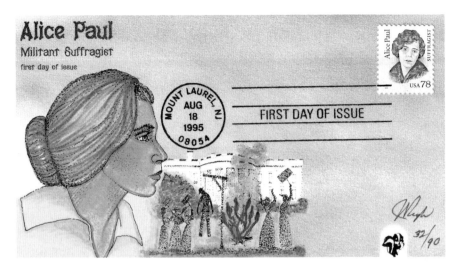

A "first day cover" for the Alice Paul stamp, postmarked in her native town; Ms. Paul lived her later years in Ridgefield. Ridgefielder Chris Calle designed the stamp. *From the author's collection.*

The same Great Americans series included Henry R. Luce, the founder of Time-Life, with a thirty-two-cent stamp issued in 1998. Luce had an estate on Great Hill Road with his wife, Clare Boothe Luce, the playwright, congresswoman and ambassador.

Robert Fawcett, who lived on Nod Hill Road, was honored with a postage stamp in 2001. It featured not his face but his painting of a man cutting ice in a bygone era. It was one of twenty different stamps on a sheet commemorating "American Illustrators" and included another, albeit brief, Ridgefielder: Frederic Remington. The famous artist of the American West moved to Ridgefield in 1909, only to die of appendicitis six months later. The stamp showed his painting *A Dash for the Timber.*

Remington takes the Ridgefielder postal prize, with a total of four stamps. His face is featured on a ten-cent stamp published in 1940 as part of the Famous Americans series. (We're not sure whether it's best to be "prominent," "great" or "famous" in the eyes of the postal service.) His painting of American Indians, called *The Smoke Signal*, is featured on a four-cent commemorative from 1961—for his 100th birthday—and his sculpture is commemorated in an eighteen-cent stamp from 1981 of his famous work *Coming Through the Rye*. Incidentally, Paul Calle of Stamford, father of Chris Calle, designed that stamp.

Artist Frederic Remington, shown shortly before his death in 1909, is honored on four United States postage stamps. *Photo courtesy of Buffalo Bill Historical Center, Cody, Wyoming.*

Stamps are supposed to honor people after they've died. However, Ridgefielder author and illustrator Maurice Sendak was celebrated six years before his death in 2012 with the 2006 issue of a thiry-nine-center, showing "Wild Thing." Apparently because he was still living, the stamp did not mention his name. But everyone in Ridgefield knew the Wild Thing's creator: he was prominent, great and famous.

Surprisingly, as of 2014, the United States Postal Service has failed to issue a stamp recalling noted American painter J. Alden Weir, who had a farm here that is now a United States Park Service National Historic Site, or composer Aaron Copland, who lived and worked here in the mid-1940s—see page 18. However, at least Copland is not stampless: the Caribbean Island of Grenada turned out a one-dollar stamp in his honor some years ago.

OUR MEDALISTS OF HONOR

Three Ridgefielders have won the nation's highest award, the Congressional Medal of Honor, which, since its creation in 1861, has been presented to fewer than 3,500 people.

Best known is Paul Bucha, who has lived here for a number of years and was, at least in 2014, Connecticut's only living recipient of the award. Mr. Bucha, a frequent and dynamic speaker, received the medal for heroism in Vietnam when, as a twenty-five-year-old army captain, he defended his 89 men for three days against some 1,500 enemy troops. He was wounded in the process. President Nixon presented the medal in 1970.

The earliest and first recipient who called Ridgefield home was Colonel Edward M. Knox. Then a lieutenant in the Civil War, Colonel Knox was wounded at Gettysburg in 1863. On July 2, his battery was under attack in the Peach Orchard area. They fought off three Confederate assaults, but the fourth advance overwhelmed them. "Unable to repulse this charge, and believing his guns would be captured, Lt. Knox ordered his men to lay down and play dead," says HomeOfHeroes.com. "The enemy forces ran past them in their charge, expecting to return for the guns after overwhelming the remaining Union forces. A charge by the 72d New York Infantry halted the enemy advance, forcing them to retreat, once again bypassing Lt.

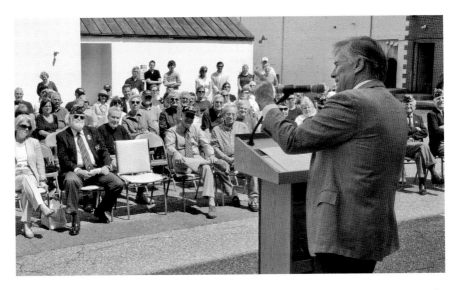

Paul Bucha, Congressional Medal of Honor recipient, spoke before a crowd at the dedication of Ridgefield's Vietnam Veterans Memorial in 2012. *Courtesy of Scott Mullin, photographer.*

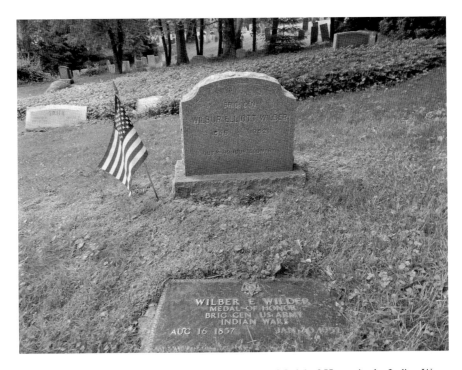

General Wilber E. Wilder, who won the Congressional Medal of Honor in the Indian Wars, is buried in Fairlawn Cemetery. *From the author's collection.*

Knox and his 'dead' soldiers, along with their guns. When the rebel forces had passed, Lt. Knox ordered his men to their feet and their guns were successfully pulled back to the Union lines, during which action Lt. Knox was severely wounded."

Colonel Knox later owned a hat company and built a forty-five-room mansion, Downesbury Manor, on three hundred acres along Florida Hill Road. There, among his regular guests was Mark Twain of Redding. He died in 1916 and is buried in the Bronx.

General Wilber E. Wilder is the only Medal of Honor winner buried in Ridgefield. In an 1882 battle with the Apaches in Horseshoe Canyon, New Mexico, General Wilder, then a lieutenant, carried a wounded comrade down the side of a mountain amid a hail of Apache bullets, an act of heroism that earned him the medal in 1896.

In 1895, General Wilder became an adjutant at West Point, then fought in the Spanish-American War, was with Pershing in Mexico in 1916 and became a World War I brigadier general in France a year later. He retired in 1927 and came to live quietly for many years at the Elms Inn on Main Street. "He was a very modest man and did not talk about his exploits," said former town historian Richard E. Venus.

General Wilder died in 1952 and is buried in Fairlawn Cemetery, where a special plaque marks him as a Medal of Honor recipient.

A COMPOSER IN SELF-EXILE

A portion of one of America's most famous symphonies was composed in Ridgefield, but few people here were ever aware of it. That's mostly because the composer—Aaron Copland—was a secret Ridgefielder.

Copland quietly moved to town in December 1945, wrote the third movement of his *Third Symphony* and began work on the final movement. The symphony is considered one of the most important American classical works of the twentieth century.

Few knew the then-recent Pulitzer Prize winner was here. "I told almost no one where I could be found," he said of his stay in Ridgefield. "I felt in self-exile, but it was essential if I was to finish the symphony." A year and a half earlier, Serge Koussevitzky, conductor of the Boston Symphony Orchestra and head of the Koussevitzky Music Foundation, had commissioned Copland to write a symphony. "It

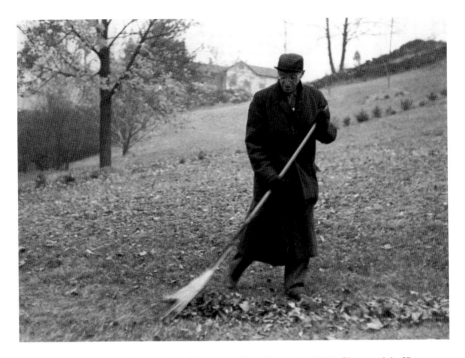

Aaron Copland, raking leaves at his Limestone Road house in 1946. *Photograph by Victor Kraft; Music Division, Library of Congress.*

would be the major concern for two years following *Appalachian Spring*," the composer said in his autobiography, *Copland Since 1943*. "I had been working on various sections whenever I could find time during the past few years. My colleagues had been urging me to compose a major orchestral work."

American composer Samuel Barber was among his cheering squad. "I hope you will knuckle down to a good symphony," Barber wrote to Copland in September 1944. "We deserve it of you, and your career is all set for it. Forza!"

The war effort—writing scores for films and radio programs for the federal Office of War Information—had delayed his focusing on the *Third Symphony* until 1945. Early that year, Copland had won the Pulitzer Prize for *Appalachian Spring*, making him a national celebrity. To escape the notoriety and concentrate on his new symphony, he needed to leave New York City, where he had been living and working. At first, he spent time in Bernardsville, New Jersey, where he completed the first two movements. But the cottage there became unavailable, so Victor

Kraft, a photographer and Copland's longtime companion, quickly found a house to rent on Limestone Road in Ridgefield.

"Conn. is cold and bleak, but self-exile is essential if I'm ever to finish up that piece," Copland wrote a friend in December 1945. It is one of dozens of letters penned in Ridgefield, many of which are in the Library of Congress. In January 1946, he told a friend, "I have stuck it out and have the third movement to show for it. One more to go and I'm done and free to go on living."

By February, he was working on the fourth movement—the one that incorporates his famous "Fanfare for the Common Man," which he had composed several years earlier. But he was also working on other projects, including the orchestral score of *Appalachian Spring*.

By March, Copland and his close friend Leonard Bernstein were making plans for the summer. Copland was assistant director of the Berkshire Music Center at Tanglewood and planned to move to western Massachusetts to be close to Tanglewood. "Lenny and I have been talking houses for the summer," he wrote to a friend. "We've had one offer of an eight-bedroom former country club sort of place—but they asked $2,300 for it!"

In April, still in Ridgefield, he wrote to Koussevitzky that "it seems …that there is a great interest among the conductors about my new symphony." He predicted the work would be ready by December.

Copland completed and polished the symphony that spring, summer and fall, in between tasks at Tanglewood and during stays in Mexico, the Berkshires and at a music colony. Koussevitzky and the Boston Symphony premiered it on October 18.

HONORING A TRAITOR

The name Benedict Arnold has become synonymous with "traitor." Yet the Town of Ridgefield did a rather extraordinary thing in 1977: it issued silver and bronze medals commemorating his leadership at the Battle of Ridgefield. The town was officially honoring one of the nation's most famous bad guys.

General Arnold wasn't always considered an evil leader who was going to hand over West Point to the English in 1780. He came to Ridgefield in April 1777 to fight the British, who had landed at Compo Beach at

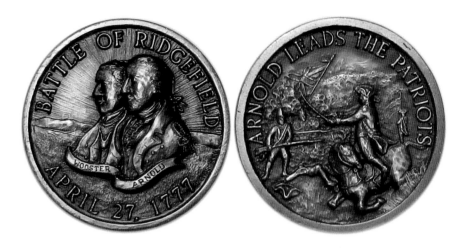

Ridgefield issued bronze and silver medals honoring Benedict Arnold in 1977, the 200th anniversary of the Battle of Ridgefield. *From the author's collection.*

Westport and had marched north to Danbury, where the redcoats burned many homes and community buildings.

On their way back to the sea, the troops passed through Ridgefield, where General Arnold and General David Wooster, leading the local militia, attacked. Arnold's horse was shot out from under him on the Main Street, but he continued to fight. Wooster was wounded along the North Salem Road (Route 116). Wooster's son, protecting his father, refused to surrender and was run through with a sword, killing him instantly. General Wooster was taken to Danbury, where he died a few days later.

The town marked the 200th anniversary of the Battle of Ridgefield with many programs and reenactments—and with the medal. On one side, the medallion depicts General Arnold as his horse was being shot from under him. The other side shows Generals Wooster and Arnold together. Ridgefield artist Gail Glissmann designed the medal. In 2002, for the 225th anniversary of the battle, the medal was restruck in bronze only.

On both occasions there were those within and outside the town who criticized Ridgefield for honoring a traitor. However, most people thought the honor was appropriate—or at least entertaining.

In *Benedict Arnold, Revolutionary Hero: An American Warrior Reconsidered* (New York University Press, 1997), Professor James Kirby Martin devotes several pages to Arnold's participation in British general

William Tryon's raid on Danbury and the Battle of Ridgefield, using it to point out Arnold's bravery and strong leadership qualities but also the lackluster support the Patriot general got from the militia and citizenry of our part of Connecticut.

"The citizen-soldiers started to break and run," Professor Martin wrote. "In desperation, America's Hannibal [Arnold] brandished his sword and rode back and forth, trying to form a rear guard to protect his fleeing column. Suddenly Arnold's horse collapsed. Having been hit by nine musket balls, the tortured animal, thrashing in death throes, had his rider pinned to the ground. An enemy soldier climbing off the ledge, rushed forward with bayoneted musket in hand. Supposedly he shouted, 'Surrender! 'You are my prisoner!'

"'Not yet,' was Arnold's alleged reply as he deftly retrieved a pistol from his saddle holster, took aim, and leveled his adversary with one shot."

Arnold freed himself from the fallen horse and crept off toward a nearby swamp. Professor Martin added, "A British officer on the scene conceded only that Arnold, like Wooster before him, had 'opposed us with more obstinacy than skill,' a statement of begrudging respect."

Near where the battle involving Arnold took place, a century-old plaque marks the burial ground of "eight patriots who were laid in these grounds, companioned by 16 British soldiers, living their enemies, dying their guests." The plaque, placed by Miss Mary Olcott, is in the stone wall just south of the entrance to Casagmo.

In 2003, a couple hundred feet south of where Arnold's horse was believed to have been shot on Main Street, a private road was built to serve several new houses. When the builders were preparing to develop the land, they asked this writer for naming ideas. The story about Benedict Arnold's fighting very near their land was related. The developers, perhaps wisely, eschewed "Benedict Arnold Way," feeling it was tainted by a name that is synonymous with traitor. However, they felt "Arnold's Way" lacked the bad connotations and still recalled the historic events of April 27, 1777. And so it is today, Arnold's Way.

A VERY PULITZER PLACE

Speaking of being honored, Ridgefield has another remarkable claim for such a small town: six of its people have won the Pulitzer Prize,

while a seventh was involved in winning four Pulitzers, and one resident was a Nobel laureate.

Allan Nevins, who won two Pulitzer prizes for historical biography (books on Grover Cleveland and on Hamilton Fish), lived in and loved Ridgefield in the 1920s. He even wrote a brief history of Ridgefield, published in a limited edition.

Richard Kluger, who lived at 14 Main Street from 1969 to 1976, won the Pulitzer in 1997 for his book that exposed the tobacco industry: *Ashes to Ashes: America's Hundred Year Cigarette War, the Public Health, and the Unabashed Triumph of Philip Morris.*

Robert Lewis Taylor, who lived on Old Branchville Road, won the Pulitzer in fiction for *The Travels of Jaimie McPheeters*, a 1959 novel about a fourteen-year-old boy and his father who trekked west during the gold rush. It became the basis for a 1960 TV series starring Kurt Russell, then nine years old.

Aaron Copland, who had just won the Pulitzer for *Appalachian Spring*, moved to Ridgefield in December 1945 to work on his now-famous *Third Symphony*. He completed the third movement and possibly the fourth movement while here (see page 18).

Westbrook Pegler, the columnist who lived here, won a Pulitzer Prize for his expose of mobster George Scalise and other racketeers (see page 58).

Lee B. Wood, who lived in Ridgebury from 1934 until 1979, was editor and president of the *New York World-Telegram and Sun* during a period when the Scripps-Howard newspaper won four Pulitzers.

Playwright Eugene O'Neill, who won four Pulitzer prizes, lived on North Salem Road in the 1920s and used his home, Brook Farm, and environs as the inspiration for the setting of one of his best plays, *Desire Under the Elms*. He is said to have written at least five plays here. O'Neill is the only Ridgefielder to have won a Nobel Prize, awarded in 1936.

It's interesting to note that O'Neill scholars and biographers maintain he was unhappy while living here, possibly because of the cold and perhaps because it was not near the sea. At one point, a biographer said, O'Neill believed "someone was peering over his shoulder as he wrote, and one night he thought he heard footsteps outside, going round and round the house." By 1926, Eugene O'Neill was using Brook Farm only occasionally, but in a letter to his wife written in September 1927, shortly before he sold the place, he wrote: "Going to Ridgefield made

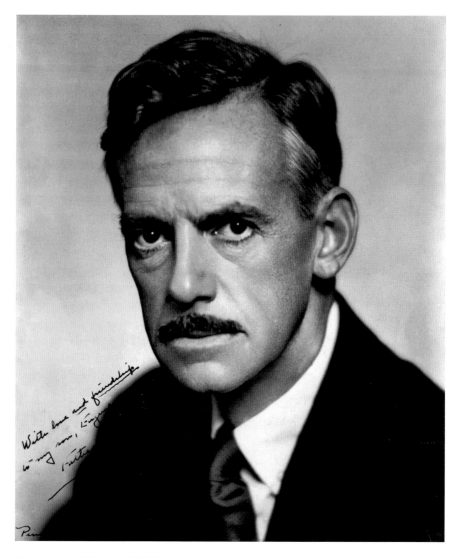

This portrait of Eugene O'Neill, taken around 1927, when he had a house here, is inscribed: "With love and friendship to my son, Eugene. Father." *From the Yale Collection of American Literature, Beinecke Rare Book and Manuscript Library.*

me sad. It's so beautiful right now, and I couldn't help feeling more keenly than ever that that's where our family ought to be. I have half a mind to open (the house) myself, except that it would be so lonely all by myself." He died in 1953.

Incidentally, in 1925, while he was living here, his daughter was born (there were those who said she was conceived here). When she was eighteen, Oona O'Neill married comedian-director Charlie Chaplin, and she remained devoted to him until his death in 1977. She died in 1991.

THE ROOSEVELTS AND RIDGEFIELD

Various presidents and their families have visited Ridgefield, but Franklin and Eleanor Roosevelt were a part of Ridgefield's history more than most presidents and their wives. Ridgefield supplied trees to the Roosevelts, and they supplied trees to Ridgefield. And in Eleanor's case, Ridgefield provided some good food.

Many landscaping trees and shrubs at the Roosevelts' Hyde Park estate came from Ridgefield's huge Outpost Nurseries in the late 1920s and the 1930s. Outpost handled dozens of big estates—even the 1939 World's Fair, many New York City parks, major universities and more. All the plantings came from its one-thousand-plus-acre nurseries, which took up much of the northeastern part of town (from Farmingville Road north to and into Danbury, including part of Bennett's Pond State Park).

Probably both Roosevelts had visited Ridgefield, but at least two appearances by Mrs. Roosevelt were documented in the pages of the *Ridgefield Press*.

In August 1936, Francis J. Bassett was driving down Wilton Road West when he stopped for a car parked in the middle of the road.

"Will you get over?" he asked the driver.

He then looked more closely and exclaimed, "Oh, please excuse me, Mrs. Roosevelt!"

"That's all right, young man," Eleanor Roosevelt replied and then drove off.

Three months later, Mrs. Roosevelt's husband took the nation by a landslide, but Republican Ridgefield went for Alf Landon, 1,203 to 556.

Incidentally, on January 30, 1939, Ridgefielders celebrated President Roosevelt's birthday with an event called the Shipwreck Dance. Presumably, the name did not refer to the ship of state because the event was aimed at raising money for the March of Dimes—more than $100 was collected, at an admission of $0.50 per person.

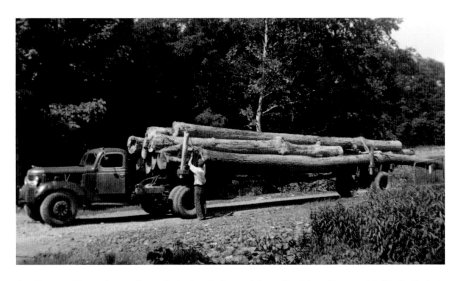

An Outpost Nurseries truck carried a load of wood from President Roosevelt's Hyde Park in 1942, destined for Ridgefield. *From the* Ridgefield Press *archives.*

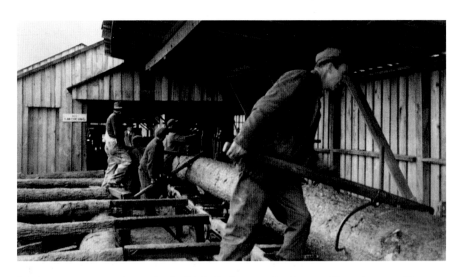

Workers maneuvered the trunk of a Hyde Park tree at the Outpost Nurseries sawmill on Route 7 around 1942. The lumber became structural parts in war vessels. *From the* Ridgefield Press *archives.*

In August 1940, Mrs. Roosevelt was spotted at the Outpost Inn, which was founded by the owners of Outpost Nurseries on the site of what are now the Fox Hill condominiums. She was quoted as calling Ridgefield "a very, very charming place." She drove herself, incidentally.

In 1942, Outpost Nurseries joined the war effort, setting up a large sawmill on Route 7 south of Little Pond (site of the old Benrus/Perkin-Elmer plants, now used for the Pond's Edge medical offices). Here, huge logs were cut to build navy patrol vessels, mine sweepers, PT boats and other small craft that required structural wood instead of iron and steel. President Roosevelt supplied trees from the 1,500-acre Hyde Park estate for this effort—some of them may have come from Outpost originally.

A 1942 article in *Southern Lumberman* noted that "one of the outstanding private timber-land owners, who is also a successful and active farmer, happens to be the President of the United States." Several hundred thousand board feet of oak for shipbuilding were cut from Hyde Park in 1942 alone, the article said. The trees had to be hauled fifty-five miles to Ridgefield, where the wood was cut and then distributed to several shipyards along the Atlantic Coast.

On April 16, 1945, four days after President Roosevelt died, hundreds filled the high school auditorium for a memorial service that included prayers by all the town's ministers. Shakespearian and movie actor Walter Hampden read "O Captain! My Captain!" Mr. Hampden, who lived in Ridgebury, knew the president and had visited him in the White House.

There was another Ridgefield-Roosevelt connection, albeit somewhat indirect. Roosevelt's vice president from 1940 to 1944 was Henry A. Wallace, who lived just across the Ridgefield line on Route 35 in South Salem. Mr. Wallace worshipped at Saint Stephen's Church in Ridgefield and, at his death in 1965, bequeathed $6,200 worth of stock in Pioneer Corn Company, a largely Wallace family business, to the church. When Saint Stephen's checked the stock's value a decade later, it was worth $800,000!

Obviously, Mr. Wallace liked Saint Stephen's—he not only attended services there, but also his funeral was there. However, he was not averse to teasing his fellow churchgoers. Once, when speaking to the men's club at Saint Stephen's, he described Episcopalians as "God's frozen few."

THREE ENCHANTING CHILDREN

Even Ridgefield children were celebrities. In 1936, the height of the Depression, the nation was looking for distractions. Often the youthful and innocent provided them: Shirley Temple was a hit in the movies; Little Orphan Annie was the star of comics and radio. And in Ridgefield, three children won the hearts of many Americans.

In April of that year, Patience, Richard and John Abbe became instant celebrities with the publication of *Around the World in Eleven Years*. Written mostly by Patience, eleven, and encouraged by their mother, Polly Shorrock Abbe, the travelogue was, according to its jacket, "by children for grown-ups. It is an enchanting odyssey."

The three Abbes were offspring of James E. Abbe, one of the top photographers of the era, and had spent most of their lives in Europe with their parents. They played with Pavlova, loved Lillian Gish and admired Thomas Mann, among the many celebrities they met. They arrived in Ridgefield in 1935, living first on West Lane just across the New York line and then on a West Mountain farm, all the time attending the East Ridge School (the old high school).

The book was well reviewed—even the crotchety Alexander Woollcott called it "enchanting." Hollywood wooed them for movies, and politicians brought Patience to Capitol Hill, where she gave a dinner party—preparing her own food.

"In spite of the whirlwind of excitement about their book, the youngsters are not the least carried away with any idea of their own importance," the *Ridgefield Press* said at the time. "They remain perfectly natural children, with something akin to an air of resignation to their indubitable and meteoric rise to literary fame."

A year later, they were gone—moving to a 320-acre ranch in Castle Rock, Colorado, purchased with the profits from the book, which sold a then-remarkable 100,000 copies. The three—mostly Patience, who essentially wrote the first book—produced two more. Patience went on to work in journalism and died in California in 2012. Richard eventually became a noted California judge; he died in 2000. John was still living in California in 2014.

Their dad, James Abbe, was a pioneer photojournalist; his pictures are owned by major museums. He worked for newspapers and magazines, doing portraits of many stars and political leaders in the 1920s and '30s, including Charlie Chaplin, Tyrone Power, Gloria Swanson and Cecil B.

De Mille. He went on to cover breaking news: the Spanish Civil War, the Nazis' rise to power and events in the Soviet Union. By the 1940s, Mr. Abbe had become a radio broadcaster in the West and later one of the nation's first television columnists. He died in 1973 in San Francisco.

A GREAT VOICE AND VOLUNTEER

Geraldine Farrar was still a teenager when she became a star, heralded around the world for her voice. One of the Metropolitan Opera's greatest

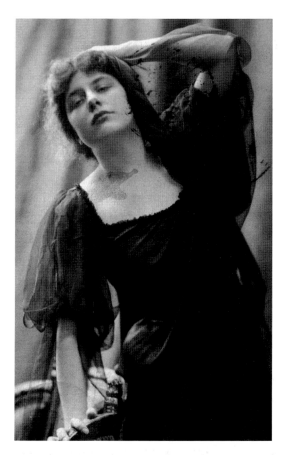

lyric sopranos, Miss Farrar spent sixteen years with the company, singing the leads in *Madama Butterfly*, *Carmen*, *Tosca* and many other productions.

"Miss Farrar was the last of a great operatic tradition set by such stars as Enrico Caruso and Antonio Scotti," the *Ridgefield Press* said in her obituary.

Born in Massachusetts in 1882, she was a daughter of Sidney Farrar, a nineteenth-century baseball player with the Philadelphia Phillies, who later lived on North Salem Road—Farrar Lane is named after him, not his more famous daughter. He and his wife, both church singers, sent Geraldine to singing lessons when she was twelve.

In 1901, she made her debut with the Royal

Geraldine Farrar, as Violetta in *La Traviata*, is pictured on a German postcard, mailed in 1905. *From the author's collection.*

29

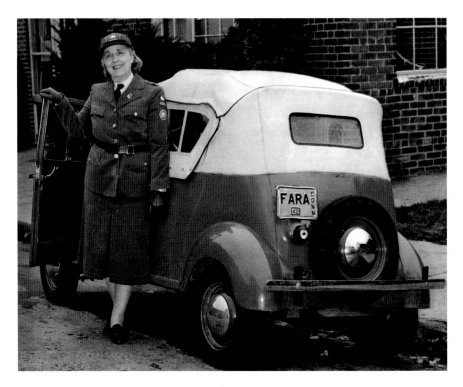

During World War II, Geraldine Farrar was active in the American Women's Voluntary Services. In the background is the *Ridgefield Press* building. The car? A 1941 Crosley. *From the* Ridgefield Press *archives.*

Opera in Berlin and so impressed Lilli Lehmann that the star took Miss Farrar as a pupil. She went on to sing with companies all over Europe. She made her acclaimed debut with the Met in 1906 and, over the following years, shared leading roles with such greats as Caruso, Scotti and Louise Homer. She knew many notables in the arts, including Camille Saint-Sains, Giacomo Puccini, Mark Twain, Sarah Bernhardt, Nellie Melba, Fritz Kreisler and Jules Massenet; she was also the lover of Italian conductor Arturo Toscanini. She made several films, including *Carmen* and *Joan of Arc*, and wrote two autobiographies, *Geraldine Farrar: The Story of an American Singer* (1916) and *Such Sweet Compulsion* (1938).

When she sang her last role in 1922, "a cheering crowd surged forward shouting her name," the *Press* said. "Outside 40th Street between Broadway and Eight was a solid mass of fans."

After her retirement, she acquired Fairhaven, a large home on West Lane. In 1954, she and her companion of fifty years, Miss Sylvia Blein, moved to a much smaller place on New Street.

During her years in Ridgefield, she did much work for the Red Cross and during the war drove for the American Women's Voluntary Services and served on the War Price and Ration Board. She also helped the Girl Scouts and served as finance chairman of the organization.

On the night she died in 1967 at the age of eighty-five, the Metropolitan Opera was performing *Madama Butterfly*, an opera Miss Farrar had starred in nearly one hundred times. That week, the *Press* suggested her epitaph might be a sentiment she herself once expressed: "Far more important than being a great artist is to become a great human being."

OFFHAND FOR THE FLIP SIDE

While Geraldine Farrar was a performer, Noël Regney and his wife, Gloria Shayne, supplied the performers, including many of the great twentieth-century stars of popular music. Yet when they wrote the classic Christmas song, "Do You Hear What I Hear?" they had no idea it would be a hit—or even published.

"Columbia Records was doing a cute Christmas song and they asked us to do something offhand for the other side of the record," Ms. Shayne told the *Ridgefield Press* in 1969.

"This is my chance to write a Christmas song for myself," Mr. Regney later recalled thinking at the time. "I had thought I'd never write a Christmas song: Christmas had become so commercial. But this was the time of the Cuban Missile Crisis. In the studio, the producer was listening to the radio to see if we had been obliterated."

He was walking home to his apartment on East Fifty-Second Street when he "saw two mothers with their babies in strollers. "The babies were looking at each other and smiling, and all of a sudden, my mood was extraordinary." He got home, sat down, wrote the lyrics and handed them to his wife, who wrote the tune.

"We couldn't sing it through; it broke us up," Gloria Shayne said.

The flip-side deal fell through, but Mercury Records decided to produce the song, performed by Harry Simeone Choral, as a lead recording. A quarter of a million copies were released just after

Songwriter Noël Regney and his daughter, Gabrielle, in 1971. *From the* Ridgefield Press *archives.*

Thanksgiving 1962 and sold out within a week. A year later, Bing Crosby did a version, and for many years and under various artists, "Do You Hear What I Hear?" sold more than one million copies a year. Now considered by some to be among the top Christmas songs of all time, the composition has been recorded on more than 120 albums by not only Bing Crosby but also other stars like Perry Como and Mahalia Jackson. The Regneys also produced two other Christmas songs, still sung today: "I Sing Noel" and "Three Wise Men, Three."

The daughter of an attorney and a professor, Gloria Shayne, née Shain, was born in Brookline, Massachusetts, in 1923, a next-door neighbor of Joseph and Rose Kennedy and their children—including John F. Kennedy. She earned a bachelor's degree in music from Boston University and headed for New York City, where she worked as a pianist and was an arranger for the likes of Stephen Sondheim and Irving Berlin.

In 1951, she met Noël Regney while she was performing at a hotel in New York City, and the two collaborated on a number of hits, including "Rain Rain Go Away," sung by Bobby Vinton; "Sweet Little Darlin'," by Jo Stafford; and "Another Go Around," by Perry Como and Doris Day. Ms. Shayne also wrote the hit song "Goodbye Cruel World," recorded by James Darren.

The Regneys moved to High Ridge in 1969. After their divorce in the mid-1970s, she moved to Stamford, but Mr. Regney remained for many years in Ridgefield, where he was a frequent performer—often at benefits—and could also be found playing the piano at the Elms Inn. He also often made appearances in schools.

A charming man with a deep voice whose accent reflected his native land, Mr. Regney was born in France as Leon Schlienger. He eventually took that name and spelled it backward—subtracting the LHCS and changing I to Y—to create Noël Regney. During World War II, the German army drafted him; he had grown up in Alsace near the German border and could speak German. He soon deserted and joined the French resistance, acting as a double agent for the French, and was once wounded when he led Nazi troops into an ambush.

After the war, he came to the United States as a working musician. After his collaborations with Ms. Shayne, Mr. Regney also wrote songs on his own, including several musicals. He also wrote the English lyrics for "Dominique," the 1963–64 top hit by the Singing Nun. In 1975, he wrote the five-part cantata, "I Believe in Life." "Writing it," he said in 1977, "was like coming back to my first love. I began to think this would be my musical testament, something lasting."

He died in 2002 in Brewster, New York, at the age of eighty. Gloria Shayne Baker, who had remarried, died in 2008 in Stamford, at age eighty-four.

THE LAST MAN

One of Ridgefield's most unusual social organizations began on March 15, 1938. On West Lane, thirty-one veterans of World War I sat down to dinner at the old Kane Inn (now Bernard's). It was the first meeting of the Last Man's Club, and it would be fifty-one years until the last meeting.

Thomas Shaughnessy was the last man. *From the* Ridgefield Press *archives.*

Harry E. Hull, longtime grand marshal of the Memorial Day Parade and the town's first selectman for several terms, was elected the first president of the club, the only organization of its kind in Connecticut, though similar clubs were found elsewhere and were also established for World War II veterans.

Each year, on March 15—the anniversary of the founding of the American Legion—members would meet at a table set for thirty-one people. When a member died, his plate was turned upside down, and a toast was drunk in his memory: "To our dear departed comrade, may God and this club preserve his memory."

The banquets were to continue until the last man died.

Though gradually decreasing in members, the club continued to meet annually, and by 1975, only five of the thirty-one were able to make it to the dinner. Many were dead, some were ill and others lived too far away to attend. By 1985, two men sat at the Last Man's Club banquet table with twenty-seven overturned plates. Only Mr. Hull and Thomas F. Shaughnessy could attend the dinner. Almost all the other members were dead. In 1989, Thomas Shaughnessy became the last man.

Born in New Canaan in 1900, Mr. Shaughnessy had sailed the world as a radio operator in the United States Navy and later on freighters and ocean liners. By 1930, he had settled on shore, buying a house on High Ridge, opening a tree surgery business and serving as Ridgefield's tree warden until 1976. He became a commander of the American Legion and belonged to Rotary and the Knights of Columbus. He continued to keep in touch with the world of his youth through ham radio.

In a 1974 interview, Mr. Shaughnessy reflected on his world travels and his Ridgefield years, saying, "I wouldn't want a life unless it was interesting."

He died at ninety-two in 1992—having for three years lived the life of the last man.

RIGHTEOUS AMONG THE NATIONS

When he lived in Ridgefield, Varian Fry rarely talked about war, much less his part in it. He was more likely to chat about his irises or perhaps the state of classics instruction at Ridgefield High School, where he did some teaching. However, by the late 1990s, twenty years

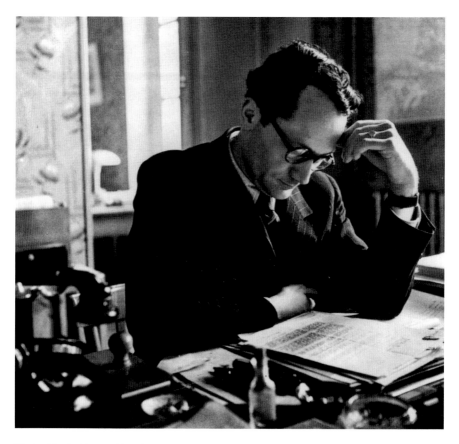

Varian Fry in 1941 at his office on the Boulevard Garibaldi in Marseilles. He helped save thousands of people from the Nazis. *Courtesy of the United States Holocaust Memorial Museum photo archives.*

after his death, Mr. Fry was being recognized around the world as one of the unsung heroes of World War II. A non-Jew, Mr. Fry is credited with saving the lives of some two thousand Jewish artists, writers and scholars wanted by the Nazis.

As a volunteer agent for the World Rescue Committee, this scholarly intellectual spent fourteen months in Marseilles in 1940 and 1941, sneaking out countless Jews and others wanted by the Nazis—among them painter Marc Chagall, sculptor Jacques Lipchitz, painter and poet Max Ernst and writer Hannah Arendt. "I stayed because the refugees

needed me," he later wrote. "But it took courage, and courage is a quality that I hadn't previously been sure I possessed."

His exploits—and his lack of support from the United States government, which helped to get him expelled from France—are detailed in his 1945 book, *Surrender on Demand*, reissued in 1997. His story has been told in major exhibits at the Holocaust Memorial Museum in Washington (1993–94) and the Jewish Museum in New York City (1997–98).

France awarded him the Legion of Honor in 1960, and in 1996, Israel posthumously gave him the "Righteous Among the Nations" award, presented to gentiles who helped to save Jews; he was the first American ever so honored. At the ceremony, United States secretary of state Warren Christopher apologized for Mr. Fry's treatment by the United States government during the war.

In 2000, both a biography (*A Quiet American: The Secret War of Varian Fry*) and a movie—a Showtime film starring William Hurt as Fry and produced by Barbra Streisand—were done about his rescue work, and he was being heralded through exhibits on three continents. Mr. Fry, who worked as a writer and editor, lived on Olmstead Lane and later in Farmingville from 1956 until shortly before his death in Easton in 1967.

THE HISTORICAL DETECTIVE AND HIS CLOCK

How did a veteran of army intelligence who had been writing for comic books and helping run the family contracting business wind up a Smithsonian Institution curator and author of many volumes of history?

"One day, I bought a clock, the first clock I had ever owned in my life," Silvio A. Bedini told me in 1989. It was no ordinary clock, however. Uncovered in a mouse nest–filled crate in North Salem, New York, the timepiece turned out to be a priceless "Silent Night Clock," with a quiet mechanism invented in 1656 for Pope Alexander VII "because he was an insomniac."

That North Salem antique inspired him to study and write about ancient clockmakers. His reputation as a specialist in the field became so widespread that the Smithsonian wooed him for five years before, in 1961, Mr. Bedini went to Washington to become a curator. "From the first day I was there, I felt that's where I should have been all my life," he said.

An ancient clock uncovered in North Salem led Silvio Bedini to a Smithsonian career that included twenty books of history. *From the* Ridgefield Press *archives.*

Mr. Bedini's interest in history started much earlier than the clock purchase, however. He was born in 1917 on North Salem Road, and as a boy, he would walk to town along that road, wondering at the historical markers along the way (it was the route of the Battle of Ridgefield). His real awakening came when a librarian allowed him to visit the dank, dusty historical room in the Ridgefield Library basement, where, among other things, he could view—but not touch—the sword of Sergeant Jeremiah Keeler, presented to him by the Marquis de Lafayette for heroic service in the Revolution. "It was a special treat to be allowed into the library's 'Holy of Holies,' even under the librarian's watchful eye," he said. "I never forgot what I had seen and could recall details of the weapon for years to come. I doubt that many Ridgefielders were even aware of the room's existence."

During World War II, he left college to volunteer for the Army Air Corps but wound up in G-2 intelligence at Fort Hunt, Virginia, a facility so secret it was blown up as the war ended. After his discharge, he returned to the family business, wrote for children's magazines and comic books and did freelance research for the *Encyclopedia Americana* and *The Book of Knowledge*.

In 1958, he was asked to write a "brochure" about the history of Ridgefield for the town's 250th anniversary. In only three months under his extensive, painstaking research, the brochure turned into *Ridgefield in Review*, 411 pages long and the only modern history of the town. After joining the Smithsonian, his talent for careful research and his interest in the "little men" of early science led him to write some twenty books of history dealing mostly with such subjects as clockmakers, navigators, mapmakers, surveyors and "tinkers" but also including a Renaissance pope and his elephant. He won many awards for his work, including, in 2000, the Leonardo da Vinci Medal, "the highest recognition from the Society of the History of Technology."

Though he retired in 1987 as deputy director of the Smithsonian's National Museum of American History, Mr. Bedini continued to research and write books, uncovering new information on old subjects. "This is what I enjoy most," he said, "the historical detective work." He died in 2007 at the age of ninety.

PERRY'S JAPAN IN PICTURES

Silvio Bedini would probably have been fascinated by the equipment Eliphalet Brown Jr. used. An accomplished daguerreotypist, Brown is buried in Ridgefield, though he may have never seen the town.

Brown was born in 1816 in Massachusetts and began his career as a portrait painter. By 1846, he was a partner with his younger brother, James Sydney Brown, in E. & J. Brown, a New York City portrait business. Probably there he learned how to become a daguerreotypist, using an early form of photography that created images on silvered metal plates; he was already a skilled lithographer and artist.

In 1852, he went to work for Currier and Ives. A year later, he was chosen to be both a photographer and an artist for Commodore Matthew Perry's pioneering expedition to Japan in 1853. On the island of Okinawa, he took what is believed to be the first photograph ever taken in Japan, a country later famous for its Nikon, Canon, Fuji and other camera makers. Another Perry expedition artist, William Heine, captured the event in a drawing that later became a lithograph—after Brown, himself an artist, drew in the human figures (see picture on page 41).

"Apparently his known skill as an artist overcame his rather weak experience as a daguerreotypist in Perry's decision-making process," writes George C. Baxley, an expert on daguerreotypes and lithographs. "This was to prove a wise choice...Brown's skills as an artist proved just as valuable to Perry as his skills as a photographer."

Historians report that Brown shot more than four hundred daguerreotype images during his two years with the Perry expedition. Most of them have vanished. However, many of his daguerreotypes were converted into lithographs that survive in books—dozens of his images can be viewed on the Internet. Writing in *The Encyclopedia of Nineteenth-Century Photography*, Bruce T. Erickson observes, "Although, as with so many other early expeditionary photographers, the actual artifacts of his career have largely disappeared, we are fortunate in having enough access to their facsimiles to appreciate the vision and skill Eliphalet Brown Jr. brought to a difficult role."

After his expedition, Brown appears to have abandoned both art and photography, Erickson writes, and spent the next twenty years as a master and ensign in the United States Navy during the Civil War and later in the Mediterranean as secretary to the commander in chief

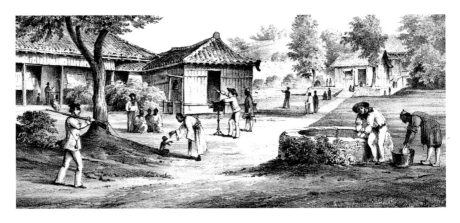

The first photograph ever taken on Japanese soil is depicted in this lithograph, showing Eliphalet Brown with his camera at center. *From "Temple at Tumai, Lew Chew," published by Ackermann, New York, 1865.*

of the United States European Fleet, aboard the flagship *Wabash*. He retired in 1875, married and "seems to have lived quietly until his death on 24 January 1886."

Mr. Brown is buried in the Coolidge family plot in Ridgefield Cemetery. That's because his wife, born Margaret Hawley of Ridgefield, married Henry Coolidge in 1847. After Henry's death, she married Mr. Brown. Both husbands and some of her Coolidge children are buried in the plot, but alas, her own stone has disappeared—perhaps under the turf. It's not known whether Eliphalet ever lived in—or even saw—the town in which he now resides for eternity.

THE OTHER CHEKHOV AND HIS STAGE

Ridgefield has also had its place in theatrical history. Since 2009, the town has had an annual Chekhov Festival, featuring professional performances of plays both new and old. But the Chekhov honored is not the Russian playwright.

Mikhail "Michael" Alexandrovich Chekhov, nephew of Anton Chekhov, was born in Russia in 1891 and, by the age of twenty-one, was already a noted actor in his homeland. By 1923, he was a director at the Moscow Art Theatre, but his innovative methods eventually

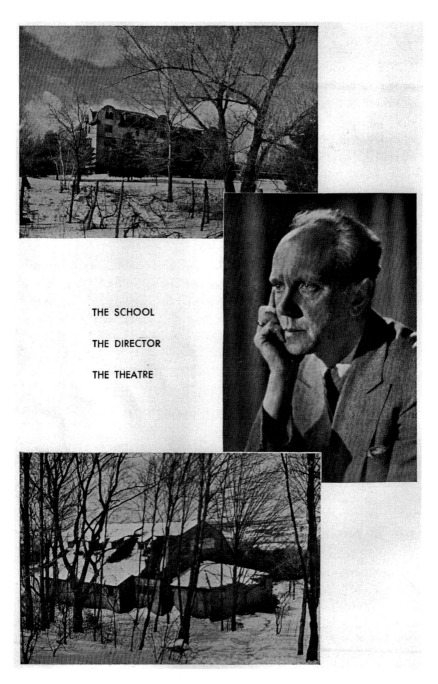

THE SCHOOL

THE DIRECTOR

THE THEATRE

A page from Chekhov Theatre Studio's 1940 catalogue shows the school, Mr. Chekhov and the barn used for performances. *From the author's collection.*

led the Communists to label him "alien and reactionary" and a "sick artist." So Michael Chekhov immigrated to Germany and then England, establishing a well-respected method of training actors. In 1939, as war was breaking out, he moved his Chekhov Theatre Studio from England to the old Ridgefield School for Boys at the north end of Lake Mamanasco on North Salem Road.

A brochure published in 1940 described the studio as "both a school for the theatre and the theatre itself." Students learned acting techniques and also staged public performances, often including their teacher. While here, Mr. Chekhov made his first appearance in an English-speaking role on the public stage—a Russian War Relief benefit program in the old high school auditorium on East Ridge, where he performed in each of the three short plays presented.

The studio had its first major production in the fall of 1939, staging Anton Chekhov's *The Possessed* at the Lyceum Theater on Broadway. "It has a genius of theatricalism," wrote Brooks Atkinson in the *New York Times*. Burns Mantle of the *New York Daily News* said, "Michael Chekhov, working from Moscow Art Theatre standards, has created a series of amazingly picturesque scenes and groupings and taught his players a great deal about acting and concentration in character portraiture…They have evidently given much study to body control and facial expression, and there is not a mumbler among them—which could profitably be noted by many Broadway players and their directors."

Students at the Chekhov Theatre Studio were offered a wide range of courses that included speech formation, eurhythmy (expressive movement), stage design and lighting, makeup, improvisations and even fencing.

By 1945, Mr. Chekhov had decided to move to Hollywood, where he not only taught but also acted in films—his portrayal of the psychoanalyst in Alfred Hitchcock's *Spellbound* won him an Academy Award nomination. Among his students were Marilyn Monroe, Jack Palance, Anthony Quinn, Yul Brynner, Gregory Peck and Akim Tamiroff. He died in 1955, but his school lives on as the acclaimed Chekhov Theatre Ensemble in New York City.

The site of Chekhov's school later became the farm of Francis D. Martin. A portion of the main building is now a house, while much of the rest of the school property is now occupied by modern homes. However, the stage on which Michael Chekhov made his American debut is still alive and well—the home of the Ridgefield Playhouse.

FOND OF THE PLAIN AND SIMPLE

One doesn't usually find a finely dressed gentleman—much less a state governor—leading a team of oxen. The man photographed with a whip and a yoke (page 45) is George E. Lounsbury, fifty-eighth governor of Connecticut (1899–1901), and the scene is his farm, the Hickories, in Farmingville about 1900.

Governor Lounsbury had lived on the Lounsbury Road farm since he was two years old and, though a Yale graduate and prominent businessman, retained it as his lifelong home. When he died in 1904, the *Ridgefield Press* observed, "Wealth and public position, when attained, often cause men to ignore those who have contributed to their success. Not so with him. He was fond of the plain, simple, unconventional customs of rural life and always kept himself in close touch with the rural people of the town."

In 1964, after the picture had appeared in the *Press* for a history feature, Katharine Bell Russell of Columbus, Ohio, formerly of Pin Pack Road, wrote to the editors: "I was five years old and remember well when that picture was taken, as I was there. My grandmother was the widow of the Rev. John Swinburne Whedon, who died while he was minister of the Methodist Church in Ridgefield, and a year later she married Governor Lounsbury. That was in 1894. We spent all our summers at The Hickories from 1896 to 1915. The oxen were Bill and Star, and the white collie was Snowland." Today, the Hickories, owned by the Brewster family, is Ridgefield's only working farm. In 1996, the town bought the development rights to 101 acres of its farmland.

George E. Lounsbury was one of the town's most influential citizens. In fact, when he died in 1904, his *Ridgefield Press* obituary reported, "he wielded a greater influence over his fellow townsmen than any other single person." He was born in Pound Ridge, New York, in 1838, but his parents moved to Farmingville two years later, and it was at the schoolhouse there and at Yale that he was educated. He began his career as an Episcopal minister but, because of health problems, entered the family business, a shoe factory in Norwalk, and headed it the rest of his life.

An active Republican, he was elected a state senator in 1895 and 1897 and governor in 1899 and 1900. (His brother, Phineas, had been governor twelve years earlier.) After his retirement, he became president of the First National Bank here (an ancestor of the Wells Fargo branch on Main Street).

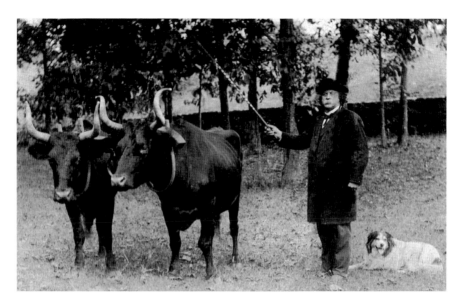

Governor George Lounsbury around 1900 with Bill and Star and his dog, Snowland. *Photo by Marie H. Kendall; the* Ridgefield Press *archives.*

"Although he was more than ordinarily successful and acquired wealth, position and prominence, he always retained an interest in the common people, with whom he mingled freely and in whose welfare he was deeply interested, as he often showed in many practical ways, unknown to the general public," his obituary said.

PART II
THE FORGOTTEN AND THE INFAMOUS

Many of Ridgefield's notable people are not well known today but are nonetheless worth knowing. A few of these were infamous, and a couple were downright eccentric.

SLAVES OF EARLY RIDGEFIELD

Like virtually every other New England community, Ridgefield had slaves and slave owners. But relatively speaking, Ridgefield seemed to have few of each.

The first official mention of slaves here occurred on February 13, 1740, when David Scott sold Vivus Dauchy, "a certain Negro woman named Dinah and a Negro boy named Peter to be servants or slaves during the period of their natural lives." The price was £200.

In 1730, Connecticut's 38,000 people included about 700 slaves. By 1770, it had more than 6,400 slaves, the largest population of any New England colony. Half of all the ministers, lawyers and public officials owned slaves, and a third of all the doctors owned them, reports Connecticut historian Jackson Turner Main.

There was no official count until 1790, the first federal census, which found only 5 slaves in Ridgefield among the 1,947 residents. That was apparently a relatively small number; Newtown, for instance, had 55

slaves among its 2,764 residents. The low number here may have reflected the town's economy more than an antislavery philosophy; Ridgefield was nearly bankrupt in the late eighteenth century.

By the 1770s, Connecticut was gradually beginning to eliminate slavery. In 1774, a law stopped the importation of slaves. In 1784, a "gradual emancipation" law decreed black and mulatto children born after March 1 that year would become free at age twenty-five. In 1797, the age was reduced to twenty-one.

Owners were already freeing many slaves, but the process wasn't necessarily simple. On November 21, 1777, Ridgefield selectmen met to examine Cyphax, the twenty-year-old slave of the Reverend Jonathan Ingersoll. Mr. Ingersoll wanted to free Cyphax, and under colony law, the selectmen had to make sure he wouldn't be a burden on the community. Records reported the selectmen "do judge him an able-bodied man and as likely to get a living as men in common in his condition are, and do therefore approve of his being liberated or set free, according to an act of the Assembly." Three days later, Mr. Ingersoll freed Cyphax.

In January 1782, Matthew Keeler freed his slave, Dick, citing his long and faithful service. However, he added a proviso, apparently required by law: "If at any time the above said Negro slave Dick should become dissolute and idle in spending his time and earnings, and thereby likely in case of any misfortune to become a charge to me or my heirs, then it shall be lawfull [sic] for me or my heirs to again take said Negro slave into my or their service during his natural life."

In the eighteenth century, most people apparently assumed a black person was a slave. However, there were free blacks, and governments even made a point of noting this. On November 14, 1789, for instance, Ridgefield received a notice from the Town of Bedford, New York, that Peg Wilson, a former slave, was freed "from a state of slavery by the last will and testament of Isaac Miller" and "is desired to pass and repass unmolested."

The 1800 census counted 951 Connecticut slaves; by 1830, the number had fallen to 25. However, it was not until 1848 that Connecticut finally abolished slavery.

Typhoid Mary Serves Up Fever

"Servants" were an important part of Ridgefield life, especially in the last half of the nineteenth and early part of the twentieth centuries. Perhaps the most famous—or infamous—was Typhoid Mary, who spread typhoid fever around metropolitan New York in the early 1900s and who was a cook for one of the many New York City families that had country homes in Ridgefield.

Once called "the most dangerous woman in America," Mary Mallon was born in Ireland in 1869, came to the United States as a teenager and became a cook in the homes of several wealthy New York and Connecticut families. Around the turn of the century, she contracted typhoid fever, but having suffered only flu-like symptoms, she probably didn't know it. However, her body became a carrier of the disease bacterium.

In 1906, while she was working for a New York banker's family, six of eleven people living in the household came down with typhoid fever. The banker hired an investigator, who eventually identified Miss Mallon and found twenty-two other cases of typhoid fever in families where she'd worked. City health officials took Mary Mallon into custody in 1907 and, without any charges or trial, kept her in an isolation cottage on North Brother Island in New York Harbor.

A brief story on the front page of the July 22, 1909 *Ridgefield Press* said: "A woman who worked as cook for Ridgefield people, and who is called 'Typhoid Mary,' has been kept a prisoner in quarantine at North Brother Island for the past two years. It is said she was responsible for six cases of typhoid fever in one family in this town. She is said to be immune herself, but can communicate the disease to others. She is known by several persons in Ridgefield."

In 1910, Miss Mallon was freed after swearing she would not cook again. However, in 1915, an investigator tracing typhoid outbreaks at a New Jersey sanatorium and a New York maternity hospital found that, using aliases to escape detection, she had worked in both places. She was returned to North Brother Island for the rest of her life, dying in 1938 but always maintaining she was not a carrier.

Health officials linked fifty-one cases of typhoid—including three deaths—to her. Details of the Ridgefield cases are unknown—many issues of the *Press* from the era no longer exist; it's not known what family she worked for.

THE HERMIT OF RIDGEFIELD

Typhoid Mary was said to have been a bit eccentric—not surprising considering the kind of notoriety she had attained. But no one is certain how a man and a woman who were well known in Ridgefield as recluses most of their lives got to be that way.

Some say George Washington Gilbert's mind snapped when his sweetheart deserted him. Others say he was just odd from the beginning. But for years he lived, usually barefoot, in his pre-Revolutionary family homestead as it fell down around him, a situation captured in many photographs and even on postcards.

Born in 1847 in that homestead, he was educated at a private boys' school in the village. Little is known of how he spent his early adulthood, but for his last forty years, he lived alone on Florida Hill Road. "By his own account, he became a hermit following the death of the girl he planned to marry," said Silvio A. Bedini in *Ridgefield in Review*.

He lived by himself and rarely visited the village, existing on a budget of about thirty cents a week. However, Mr. Gilbert was not without visitors. Hundreds of people, young and old, would call on him each year, and "he related many strange tales and yarns which gained in detail and wonder with each narration," wrote George L. Rockwell in *History of Ridgefield*.

He enjoyed posing tricky mathematical questions, such as "What is a third and a half of a third of 10?" and showing people the sword that his grandfather had supposedly captured from a Hessian soldier at the Battle of Monmouth during the Revolution. He also took people to his cellar, where there was a stone in the chimney basement that reportedly bore a striking resemblance to the profile of Queen Victoria.

Mr. Gilbert invariably dressed in a cotton shirt, overalls hung by suspenders and an old straw hat. And he wore no shoes for much of the year. In fact, the *Ridgefield Press* would sometimes announce the seasonal comings and goings of his shoes. For instance, the May 7, 1886 issue noted: "George Washington Gilbert has dispensed with his shoes," a sure sign of the "approach of summer." And on December 23, 1887, "It has been demonstrated beyond question that winter is here. George Washington Gilbert has donned his boots."

Mr. Gilbert's home literally fell apart around him, and for a while, he had to move his bed onto the hearth of the old fireplace, the chimney being the only shelter left. Finally, Colonel Edward M.

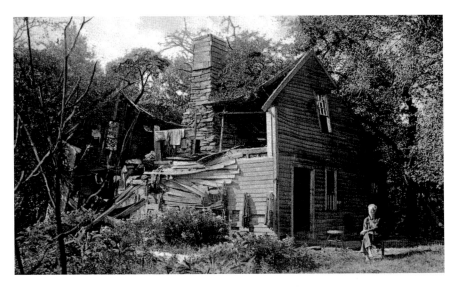

This postcard, circa 1910, shows George Washington Gilbert, seated at right, who lived in this house until a wealthy neighbor finally took pity on him. *From the author's collection.*

Knox, whose huge estate was down Florida Hill Road a bit, took pity on him. Knox had a cottage built for the hermit. However, on January 6, 1924, during a bitterly cold spell, a neighbor looked in on Mr. Gilbert and found him frozen to death.

George Washington Gilbert is buried at the New Florida Cemetery at Route 7 and Simpaug Turnpike under a stone that reads: "The Hermit of Ridgefield." His father, Jeremiah (d. 1860), and mother, Eliza (d. 1884), lie next to him.

NO MERE AMATEUR RECLUSE

Ridgefield has had not only a hermit but also a hermitess—though, officially, she was a New Yorker. Sarah Bishop lived in a tiny cave in the side of West Mountain in Lewisboro, New York, just across the Ridgefield line westward of Oreneca Road and Sturges Park.

She arrived during the Revolutionary War, but no one knows why. Several legends explain her appearance. One said she was in love

with a sea captain who deserted her. Another maintained that shortly before her wedding day, British troops invaded her Long Island home, and a redcoat raped her. Full of shame or sorrow, she ran away to this cave from which, on a clear day, she could see Long Island and the place where she spent her girlhood days.

Sarah Bishop lived on gifts of food, on wild plants and on a small garden she kept near her cave, which was little more than a hollow in some rocks. A reporter who visited her in 1804 said a few peach trees, as well as beans, cucumbers and potatoes, grew in a nearby clearing. There were also said to be many grape vines nearby. She also got some necessities from kind-hearted people on West Mountain and in Ridgefield and South Salem, whose villages she periodically visited.

A religious woman, Sarah Bishop sometimes attended services at the First Congregational Church here or the Presbyterian Church in South Salem. At the home of Jared Hoyt in South Salem, she kept some fancy dresses from her youth. She would come down from the mountain, dress at his house, attend church and return to the house to change back into her "rags."

One of the places she visited in Ridgefield Village was the home of the Reverend Samuel G. Goodrich of the First Congregational Church. The house still stands on High Ridge at the head of Parley Lane. His son, author S.G. Goodrich (whose pen name was Peter Parley), remembered as a boy seeing her:

This strange woman was no mere amateur recluse. The rock—bare and desolate—was actually her home, except that occasionally she strayed to the neighboring villages, seldom being absent more than one or two days at a time. She never begged, but received such articles as were given to her.

She was of a highly religious turn of mind, and at long intervals came to our church and partook of the sacrament. She sometimes visited our family—the only one thus favored in town—and occasionally remained over night. She never would eat with us at the table, nor engage in general conversation.

Upon her early history she was invariably silent; indeed, she spoke of her affairs with great reluctance. She neither seemed to have sympathy for others, nor ask it in return. If there was any exception, it was only in respect to the religious exercises of the family; she listened intently to the reading of the Bible and joined with apparent devotion in the morning and evening prayer.

Sarah Bishop, the hermitess, lived in a cave on West Mountain. *From* Recollections of a Lifetime *by S.G. Goodrich.*

Goodrich added, "I have very often seen this eccentric personage stealing into church, or moving along the street, or wending her way through land and footpath up to her mountain home. She always appeared desirous of escaping notice, and though her step was active, she had a gliding movement, which seemed to ally her to the spirit world."

Sarah Bishop died in 1810. According to George L. Rockwell, "the generally accepted story is that one stormy night, she left the house of one of the neighbors, who lived on the corner of the road leading up to the mountain. Wending her way up the steep mountainside to her cave, she fell, and too weak to continue her way, perished from the cold. She was found among the rocks a short distance from her cave." She was buried in an unmarked grave in North Salem.

In 1908, Dr. Maurice Enright, a physician who maintained a summer place here, wrote a novel, *The Ridgefield Tavern, A Romance of Sarah Bishop, Hermitess, During the American Revolution.* The book cast Sarah Bishop as the daughter of the operator of the Keeler Tavern ("Ridgefield Tavern"), a photograph of which appears in the book. The account is, of course, fictional.

Goodrich turned to poetry to capture the color of the old hermitess, publishing the following in 1823 under his pen name of Peter Parley in a Hartford newspaper. It's a great piece to read aloud on Halloween night.

For many a year the mountain hag
Was a theme of village wonder,
For she made her home on the dizzy crag
where the eagle bore its plunder.
Up the beetling cliff she was seen at night
Like a ghost to glide away;
But she came again with the morning light
From the forest wild and gray.
Her face was wrinkled, and passionless seem'd,
As her bosom—all blasted and dead—
And her colorless eye like an icicle gleam'd,
Yet no sorrow or sympathy shed.
Her long snowy locks, as the winter drift,
On the wind were backward cast;
And her shrivel'd form glided by so swift,
You had said 'Twere a ghost that pass'd.
Her house was a cave in a giddy rock
That o'erhung a lonesome vale;
And 'twas deeply scarr'd by the lightning's shock
And swept by vengeful gale.
As alone on the cliff she musingly sate—
The fox at her fingers would snap;
The crow would sit on her snow-white pate,
And the rattlesnake coil in her lap.
The night-hawk look'd down with a welcome eye
As he stoop'd in his airy swing;
And the haughty eagle hover'd so nigh
As to fan her long locks with his wing.
But when winter roll'd dark his sullen wave
From the west with gusty shock,
Old Sarah, deserted, crept cold to her cave
And slept without bed in her rock.
No fire illumined her dismal den,
Yet a tatter'd Bible she read;
For she saw in the dark with a wizard ken,
And talk'd with the troubled dead.
And often she mutter'd a foreign name,
With curses too fearful to tell,
And a tale of horror—of madness and shame—
She told to the walls of her cell!

MR. COPP, HIS HILL AND HIS CORNER

Anyone who's lived in Ridgefield knows its largest shopping center, Copps Hill Plaza. But few know Copps Hill—and fewer have heard of Copp himself, John Copp that is. And yet, Dr. Copp was one of the most accomplished people involved in early Ridgefield.

Copps Hill is the ridge north of Copps Hill Road and east of North Street, including the Stonecrest and Mimosa neighborhoods.

Copp is not a common name in the United States. Nor is it in England, from which William Copp set sail in 1635 for Boston. William was a cordwainer, a worker in leather, and became a well-to-do businessman, owning two houses and much land. William Copp's nine children included David, who was also a leading citizen. William died in 1713 and is buried in what is still called the Copps Hill Burying Ground near the Boston Common. His friends, Increase and Cotton Mather, are also buried there.

His son John Copp was born in 1673 and, while in his twenties, migrated to Connecticut. John's name first turns up in 1698 in Stamford. Norwalk records report that in 1701, a town meeting hired him as schoolmaster. John Copp was also among the first medical doctors in the state. He received his medical license in 1710 or 1711 and was appointed a surgeon with a Connecticut regiment that was to march to Port Royal in Canada to fight the French.

As early as 1697, residents of Norwalk were becoming interested in the American Indian land fifteen miles north. John Copp had learned surveying from his father and, around 1708, drew up boundaries for twenty thousand acres, roughly the south half of the present town. In September 1708, Copp and two other men, representing Ridgefield's first twenty-six settling families, paid the Indians £100 for this "first purchase" of land.

Copp was elected recorder—now called town clerk—by Ridgefield's first town meeting in 1709. He helped lay out the town and its Main Street, acted as a physician and became the first schoolteacher, instructing the children in a small meetinghouse somewhere near the present Methodist church. Although the hill was named for him, Copp had no land in Ridgefield. He remained a Norwalk resident and probably stayed here for periods with settling families. Copp's last entry in the town records came in 1713, when the Reverend Thomas Hauley, who had just become the town's first minister, succeeded him at both recording and teaching.

Commenting on Copp's four years in helping the settlers in Ridgefield, Silvio Bedini writes in *Ridgefield in Review*: "In view of Copp's various public trusts during the first several decades of the 18th Century, it is surprising to find that he was able to serve as town register and school teacher from 1709 to 1713."

Before, during and after his work with Ridgefield, Dr. Copp was active in the civic and ecclesiastical life of Norwalk, of Fairfield County and of Connecticut, serving as state representative, county surveyor and a church deacon. Copp's name is kept alive in Norwalk, where Copps Island lies just off the harbor; he once owned it.

In the 1720s, Copp had a farm in the Wilton section Georgetown, then part of Norwalk, but he probably did not live there. Nonetheless, the southeast corner of Ridgefield—now Branchville—was called Copp's Corner back then. That name did not last long, however.

John Copp's name made its final known appearance in Ridgefield records in 1739, when he came to town to attend the installation of the new Congregational minister, twenty-six-year-old Jonathan Ingersoll. Mr. Hauley had died the year before.

THE EBENEZER OLMSTED SCANDAL

Not all the early town officials were as dedicated as John Copp. One prominent leader got himself—and Ridgefield—into a lot of trouble more than two centuries ago.

Lieutenant Ebenezer Olmsted was part of Ridgefield's leading society, an officer in the continental militia who served under people like Colonel Philip Burr Bradley at places like Ticonderoga and the Battles of Ridgefield, Long Island and Germantown. He was with Washington at Valley Forge, according to *The Genealogy of the Olmsted Family in America*.

He was also married to Esther Ingersoll, daughter of the Reverend Jonathan Ingersoll, second minister of the First Congregational Church; her brother, Jonathan, was to become lieutenant governor of Connecticut (his son, Ralph, became a United States congressman). Olmsted had a house on Main Street, just south of the meetinghouse, a prime piece of real estate. But he wound up under arrest and lost all his possessions, including his home and even "his desk."

It all began on December 21, 1780, when the town meeting appointed Lieutenant Olmsted "to collect the state tax for the year ensuing." The appointment was for one year, typical of tax collecting assignments, but it indicated he was held in high esteem. However, six years later, in 1786, the town meeting voted to "accept the resignation of Lt. Ebenezer Olmsted of his office of collector of ye state taxes on ye list of 1780, on conditions of his accounting with and paying to the Select Men the full that he has collected and received on the rates made on said list, and deliver up said rate bills and warrants to the Select Men."

Olmsted had apparently pocketed what he'd collected, quite possibly to pay for that Main Street spread he purchased two years after being named tax collector. He paid £300 for the homestead, after selling his Wilton Road West place for only £75. For the next six years, the town's records are peppered with reports of how it was dealing with the crisis. And a crisis it was.

First, the selectmen arrested Olmsted and confiscated his thirteen-acre homestead and all his possessions, including other land, eight tons of hay plus oats and flax and "his desk." They also took "2,258 Continental Dollars," which were virtually worthless. His old commander, Colonel Bradley, headed a committee to auction off the homestead, but that brought in only £120, far less than was owed (although the amount owed is never stated). Colonel Bradley was sent to Hartford, apparently to see if Ridgefield's state tax debt could be forgiven, but the state was insistent. The war had been costly, and the state needed money.

Finally, abandoning hope of ever getting the money from Olmsted, the town went into debt, borrowing "such sums as shall be necessary to settle ye demands the state treasurer has against the town." So poor and desperate was Ridgefield that, in 1792, it voted to sell its set of "books containing the laws of ye United States."

Olmsted died in 1801 at the age of fifty-three, but his wife lived forty-six more years, dying in Saint Louis, Missouri, in 1847 at the age of eighty-seven. No gravestones can be found in town for him, so he may have left Ridgefield in disgrace.

THE SWAGGERING RACKETEER

Stealing from public trusts has been going on for as long as people have been in charge of money. Some did it professionally, however. An old Ridgefield mansion that's now home to priests was once the house of a noted racketeer who extorted huge amounts of cash from New York City businesses.

George Scalise was a shady character. However, he had the misfortune to run up against a soon-to-be Ridgefielder, who exposed his misdeeds, and a soon-to-be United States presidential candidate, who successfully prosecuted him. Scalise wound up in jail, and columnist Westbrook Pegler wound up with a Pulitzer Prize.

Scalise was the "swaggering president of the Building Service Employees' International Union," as one New York newspaper put it around 1940. He was also said to be an associate of mobster Dutch Schultz. In the 1930s, he bought an estate overlooking Lake Mamanasco as a weekend retreat.

Scalise was arrested in 1940 by the crusading district attorney Thomas E. Dewey, later governor of New York and the 1944 and 1948 GOP presidential candidate. He was charged with extorting $100,000 from hotels and contracting firms. ($100,000 then would be about $1.6 million today.) But the arrest came only after Pegler had exposed Scalise in a series of antiracketeering newspaper columns that won him the Pulitzer.

In a 1940 piece, Pegler described how Scalise had acquired the twenty-seven-room mansion on Tackora Trail, apparently with union funds. "A remarkable proportion of Mr. Scalise's fellow officers of the union have criminal records, and he reached the presidency by private arrangement with the officers and without any vote, direct or indirect, of the rank and file chambermaids, charwomen, window cleaners, janitors and other toilers," wrote Pegler. He also noted that just across North Salem Road from his Ridgefield mansion was the town poorhouse (see page 86).

Mr. Pegler moved to Ridgefield a year later, buying a one-hundred-acre estate on Old Stagecoach Road. The often-caustic columnist lived here until 1948 and later fell out of national favor after years of bitter, anti-Communist columns. (In a 1950 column, he described Ridgefield as "an old aristocratic town of moldering white mansions on a white main street" that "has quietly become infested with wealthy Sixth Columnists.") He died in 1969 in Arizona, at age seventy-four.

Racketeer George Scalise's mansion at Lake Mamanasco is now owned by traditionalist Catholic priests. *Photograph, circa 1920 by Joseph Hartmann,* Ridgefield Press *archives.*

In the 1940s and '50s, "Villa Scalise" became the Mamanasco Lodge, a resort operated by the Hilsenrad family, and by the 1960s, it was owned by the Jesuits, who set up a retreat house there and called it Manresa. Today, it's still a retreat house as well as a school, operated by the Society of Saint Pius X.

THE ELEPHANT IN THE YARD

The circus was a form of entertainment that was immensely popular in the nineteenth century. Traveling circuses visited communities large and small across the eastern United States. Ridgefield had a more-than-passing connection with American circus history. One of America's circus pioneers was born here, and some four-legged stars of early circuses died here.

Aaron Turner was born in Ridgefield in 1790, said to be the illegitimate son of one Mercy Hony. When he was nine, he went to live on the farm of a court-appointed guardian, Dorcas Osborn, at the corner of Saw Mill

and Turner Roads (the house is no longer standing). Turner eventually inherited the farm and much land in the Ridgefield and Danbury portions of Ridgebury.

However, farming was not his calling. By age thirty, he was associated with the circus world, part owner of a troupe that had sprung up from one of the circus families who lived in nearby New York State. By this time, 1820, his seven-year-old son, Napoleon, was already a trick rider in a New York City circus. After eight years, Turner the elder had a traveling circus of his own, serving as ringmaster. In 1836, he hired a young Bethel man named Phineas T. Barnum as his ticket seller, secretary and treasurer.

During the winter, Turner's circus stayed at his Ridgebury farm, which included land along the west side of Ridgebury and Turner Roads. Many circus animals were reportedly housed there and at farms in the neighborhood. A number of these animals were believed to have been buried in the old fields along the western side of northern Ridgebury Road—including at least one elephant.

"Turner's circus was one of the most important and popular in the country," wrote Ridgefield historian Silvio Bedini, who said both sons, Timothy and Napoleon, were "skilled riders." Turner's daughter married George Fox Bailey of Somers, New York, who later managed the circus and took it over after Turner retired. Barnum, of course, went on to found his own circus, which survives today in the Ringling Bros. and Barnum & Bailey Circus. (In the 1870s, George Bailey was a partner of Barnum, but the "Bailey" in the circus name was a distant relative, not him.)

Barnum described Turner as a genius, a man of untiring industry, a practical joker and a good judge of human nature, reports William Slout of the Circus Historical Society.

Turner eventually retired to the quieter life of operating a hotel, Turner House, in Danbury facing the Main Street green. He died in 1854, and his hotel, which subsequently became a Knights of Columbus Home, was torn down in the 1960s to make way for—alas—a used car lot. Today, a Walgreen's pharmacy is there.

Turner Road, of course, recalls Aaron. So does the Turner Hill subdivision, built in the early 1990s off the south side of Turner Road. Roads there are named for some of the circus families that lived in Ridgefield and nearby, including Hunt, Howes and, of course, Barnum.

PART III

LANDMARKS OLD, NEW AND GONE

Many buildings, monuments and even roads mark Ridgefield as a town full of fascinating history and lore.

GOOD RISES FROM THE ASHES

Saint Augustine believed that evil has value because good can come from it. Optimistic Ridgefielders might have had a similar feeling more than a century ago after a horrific fire leveled much of the commercial center of town. Good soon rose from the ashes.

About nine o'clock on Sunday night, December 8, 1895, the fire broke out in Bedient and Mead's furniture store—also the town's undertaking business—at the corner of Main Street and Bailey Avenue. The cause was never ascertained, but arson was a possibility.

The blaze quickly spread, and by the time it burned itself out at three o'clock on Monday morning, ten buildings in the village were destroyed at a loss of more than $100,000—in today's money, more than $3 million. Among the structures burned to the ground were the town hall, only twenty years old; thirteen stores and offices, both to the north and south of Bailey Avenue; and the Masonic Hall housing the *Ridgefield Press* office and printing equipment, just south of the town hall.

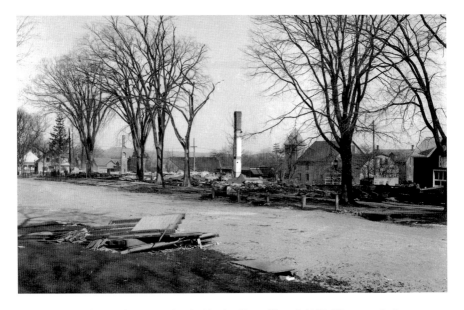

The east side of Main Street was leveled in the Great Fire of 1895. The town hall was about where the elm at the farthest right stood. *Photograph by Joseph Hartmann; the* Ridgefield Press *archives.*

Opposite: The wooden town hall, built in 1876, was destroyed in the Great Fire of 1895. *From* The History of Ridgefield *by the Reverend Daniel Teller.*

As the *Press* reported that week, "All night long…the citizens of this town watched with feelings of consternation the spread of the biggest conflagration that ever swept through the village, and no adequate means were at hand to check the awful destruction which was the result of it."

There was no fire department, and there was no water. The only tool townspeople had at hand was dynamite, and they blew up the burning Masonic Hall in an attempt to stop the southward movement of the blaze. It didn't work.

The *Press* still managed to get its weekly issue out on time that week, despite losing its home, and editor E.C. Bross heaped scorn on what he called the conservative citizens of the town who had felt no need for an organized fire department—protection, he believed, that might have saved the center.

The Great Fire of 1895 was a lesson learned. Four months later, the town created the "Fire District of Ridgefield," later called the Borough

of Ridgefield, to levy extra taxes on villagers to support a fire department and water supplies.

Almost immediately, work began on a new town hall, and the building was completed on November 21, 1896—less than a year after the conflagration. Unlike the wooden town hall that burned down, the new building was made of brick. It cost $16,000 ($414,000 in 2013), three times its predecessor's price, and was financed by a group of wealthy "summer people." One reason for the high cost: it contains a massive, built-in, three-story, walk-in vault that was as fireproof as the technology of the era allowed. It is still used today.

The town hall also contained a bay at the rear to house the equipment for a new fire department, approved at a January 23, 1897

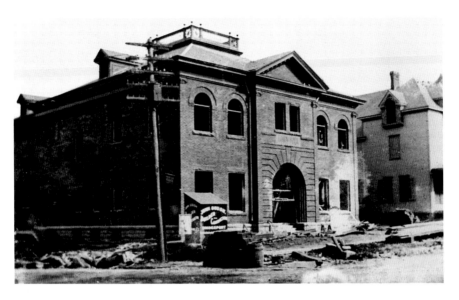

The new town hall, under construction in 1896, was much more fire resistant. *From the* Ridgefield Press *archives.*

town meeting. In February, Ridgefielders officially formed that fire department. Charles S. Nash was elected the first chief. Two companies were created: the Caudatowa Hook and Ladder Company and the P.C. Lounsbury Engine Company, which operated the pumper.

But what was the pumper to pump? Work had begun shortly after the fire to create a public water supply for the center of town. On June 13, 1900, the Ridgefield Water Supply Company began providing service to the village, including hydrants, from a reservoir created from Round Pond on West Mountain. And since a supply of public water was now available, the town also opted to build a village sewer system, which was completed in June 1902. Even gaslights were installed in the resurrected center.

The Great Fire of 1895 had moved Ridgefield into the twentieth century, literally and figuratively.

BEFORE DUNROVIN WAS DONE

Fire has taken its toll on a number of Ridgefield landmarks, not the least of which was Dunrovin.

In 1902, only a year after Ridgefield Republican governor George E. Lounsbury left office, Melbert Brinkerhoff Cary of West Lane ran for governor on the Democratic ticket. He had been chairman of the Democratic State Central Committee for several years. Cary lost to a Meriden Republican named Abiram Chamberlain but remained a power in state government, as well as influential in Ridgefield goings on. He was also a delegate to the 1908 Democratic National Convention that nominated the golden-throated William Jennings Bryan for president. (Bryan spoke in Ridgefield in 1907—"Main Street looked as though half the population of the town had turned out," the *Ridgefield Press* reported.) However, Bryan was as successful in his bid as Cary had been in his.

A Princeton man, Melbert Cary had been a lawyer in New York City; his specialty was patents. But he was also a writer whose books included *The Connecticut Constitution* (1900) and *The Woman Without a Country* (1934), and when he was in his eighties, he wrote the novel *Back Stage* (1938). He was also longtime president of the board of Flower Hospital in New York. He died in 1946 at the age of ninety-three; at the time, he was the oldest living Princeton graduate. His son, Melbert B. Cary, was an internationally known graphic artist and authority on type, who himself wrote several books, including a loving tribute to his mother, Julia M. Cary.

In 1936, Cary's estate, which he'd called Wildflower Farm, became the home of another lawyer, William Matheus Sullivan, who called it Dunrovin. Sullivan's clients included the Metropolitan Opera and some of its stars, and his connections with those leaders in the arts led to his creating the Dunrovin Music Festival, which began in 1938 and brought leading opera and chamber music personalities to a privately created theater on the estate. Mr. Sullivan had converted a carriage house into the theater, modeled after Frederick the Great's opera house in Bayreuth, Germany, and performers on its stage included such great voices of the era as Lily Pons, Grace Moore, Lawrence Tibbett, Edward Johnson and Geraldine Farrar. In 1940, when war had broken out in Europe, Mr. Sullivan began turning over the proceeds from the concerts to the Red Cross. Suspended during the war, the festivals resumed in

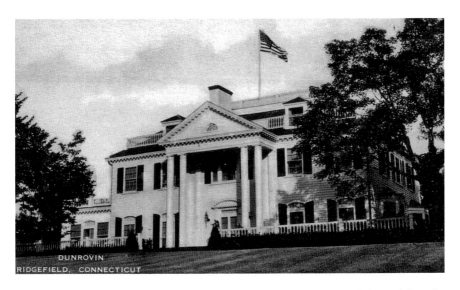

Dunrovin was home of a politician-author and of a music patron-lawyer. It burned down in the 1970s. *Postcard circa 1940, from the author's collection.*

1946 but ended with Sullivan's death in 1947. The playhouse was also the scene of many private concerts, some benefiting such causes as Danbury Hospital.

A native of Brooklyn, New York, Mr. Sullivan also sponsored young artists who went on to become leading singers and musicians. An art and antiques collector, he owned Van Dyke's *The Holy Family*, which he hung in his playhouse. He was often seen in the village with his English sheepdogs, one of which was the gift of his friend, the Duke of Windsor, when he was king of England. In his will, Mr. Sullivan established the William Matheus Sullivan Musical Foundation, which, to this day, awards grants to promising musicians to help with their studies.

While the playhouse still exists as a private home, Dunrovin's house is no more. One Sunday in the 1970s, the owners cleared still-hot ashes from a fireplace, put them in a container on a wooden porch and went to New York. The ashes somehow ignited the wood, and Dunrovin burned to the ground in a spectacular middle-of-the-night blaze.

HIDDEN SCHOOLHOUSES

Ridgefield, at 25,000 people, has nine public schools. But back in the 1800s, when it had about 2,200 people, Ridgefield operated more than a dozen schools. The difference, of course, was their size—they were mostly one-room schoolhouses. At least seven still exist, but most are never noticed as schoolhouses.

One-room schoolhouses were in use here from the early 1700s, and a dozen were functioning in the mid-1800s. In 1915, some closed when the new Benjamin Franklin Grammar School opened on East Ridge (later called the East Ridge School, then Ridgefield High School; it's now the core of the Richard E. Venus Office Building). Others closed in 1925 and the last in 1939.

The most prominent schoolhouse still extant is the West Lane, or "Peter Parley School," at West Lane, South Salem and Silver Spring Roads. Dating from the mid-1800s on a foundation from the 1700s, it is now a museum, open a half dozen Sundays each year.

Branchville Schoolhouse on Old Branchville Road is used mostly for storage today and still looks like an old schoolhouse. So does Titicus Schoolhouse (with two rooms, not one), which was in use until 1939. Located on the corner of North Salem Road and New Street, it's now the American Legion Hall.

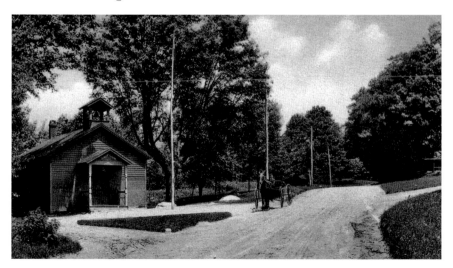

The West Lane Schoolhouse, also called the Peter Parley School, is now a museum. *Postcard circa 1910 from the author's collection.*

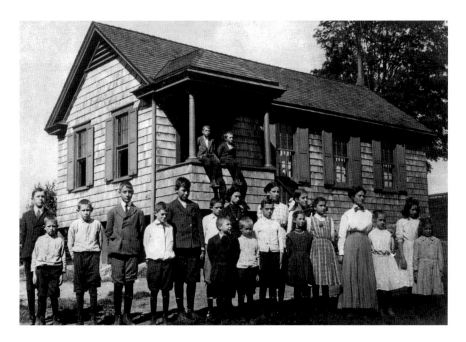

Limestone Schoolhouse, with teacher and scholars, around 1912. The building is now part of a house. *From the* Ridgefield Press *archives.*

Other schoolhouses have been converted into homes. Limestone Schoolhouse is a home just north of the Limestone Service Station on Danbury Road. One of the old Scotland or Scotts Ridge schoolhouses is a home on North Salem Road. The West Mountain School, used as a rental residence, is on the Innisfree estate off West Mountain Road. Ridgebury Schoolhouse is a home on Ridgebury Road, about opposite Old Stagecoach Road.

Yet another schoolhouse still stands but not in town. Farmingville Schoolhouse was moved to North Salem, New York, where it has served as an artist's studio for many years. It still has a bell in its belfry.

The Whipstick Schoolhouse became a wing of a larger home for many years but was razed when the house was torn down in the late 1990s to make way for a bigger house. The Flat Rock, Center, Bennett's Farm and Florida schoolhouses were lost long ago.

THE SCOTTS OF SCOTLAND

While some towns name schools after people, Ridgefield names its schools after locations, usually nineteenth-century school district names. The school board may avoid controversy that way; naming buildings after people tends to spark sometimes-heated debate over whether the person was worth naming a school after. Two such geographically named schools, however, have snuck in recognition of an old Ridgefield family.

Scotland Elementary School is named for an old school district consisting generally of the neighborhood around Lake Mamanasco and Pierrepont Pond. The fact that many members of the Scott family settled so early—probably by the 1730s—in this area and stayed there so long made them a "first family," so to speak, and probably inspired the Scotland name. As early as 1750, land records were making reference to "Scots land" (with only one t). A 1751 deed to Job Smith describes four and one-half acres "lying west of Scots land on ye Great Hill." One can see how easily the transition from Scots or Scott's land to Scotland could occur.

The name "Scotland" may just have been coming into use by the 1830s. The earliest mention of Scotland occurred in an 1835 deed for two acres "in Scotland District so called." Another name, Scotts Ridge, was more widely used. From 1843 to 1864, at least six references to Scotts Ridge are found in the land records, but not one mentioning Scotland District. Even Beers atlas in 1867 labels the school district as "Scotts Ridge." However, by 1878, in his *History of Ridgefield*, the Reverend Daniel Teller is calling it Scotland District.

In 2002, when the school board was looking for a name for its new middle school, several were proposed, including North Ridge, Mamanasco and John Sturges (for the late chairman of the school building committee). Scotts Ridge won out on a six to two vote.

People named Scott were living in Ridgefield by 1712, when David Scott I of Fairfield bought lot number 13 on Main Street at Catoonah Street. The house he built remained on the old lot for two and a half centuries but was eventually dismantled, moved and rebuilt on Sunset Lane, where it today serves as the headquarters of the Ridgefield Historical Society. It is believed that David came from Ireland but that his family was originally from Scotland.

Historian Silvio Bedini uncovered a lawsuit involving David's wife, Mary Scott, whom David apparently abandoned back in Ireland.

Know all men by these presents that I Thomas Scott of Ridgfield in the County of Fairfield and State of Connecticut, for the Consideration of the Sum of One Hundred Thirteen Dollars Thirty three Cents & three Mills. Received to my full Satisfaction of Jesse Jervis of Norwalk in said County, do give, grant, bargain Sell and Confirm unto him the said Jesse Jervis and to his Heirs and Assigns forever, Three Roods of Land (be the same more or less) with the Dwelling house standing thereon lying in said Ridgfield. Near the Sawmill now Owned by Matthew Rich and others, and is Bounded West and North by Highway, South by Epenetus Hows Land & East by the River. ———

To have and to hold the above granted and Bargained premises with the appurtenances thereof unto him the said Jesse Jervis and to his Heirs and Assigns to his and their own proper use and behoof, and also I the said Thos. Scott do for myself my Heirs Executors and Administrators Covenant with the said Jesse Jervis his Heirs and Assigns that at and untill the Ensealing of These presents I am well Suized of the premises as a good Indefeasible Estate in fee Simple & have good right to Bargain and Sell the same in Manner and form as is above written and that the same is free and Clear of all Incumbrances whatsoever. —— And furthermore I the sd Thomas Scott, do by these presents Bind myself and my heirs forever to warrant & Defend the above granted and Bargained premises to him the said Jesse Jervis and to his heirs and Assigns against all Claims and demands whatsoever —— In witness whereof I have hereunto Set my hand and Seal this ——— day of December AD 1796 ——

Signed Sealed & Dilivered
in presence of

Thomas Scott

A 1796 deed of Thomas Scott, one of the many Scotts for whom the Scotland District was named. This land, however, is probably at nearby Titicus. *From the author's collection.*

She came to America, and her children later followed. She sued her husband—perhaps for ditching her; she won and got some land in Ridgefield as a result. Mr. Bedini suspects she was the first person named Scott to live in what was to become the Scotland District. Her children went on to found a large Ridgefield family that still has members living in town today. It included four men who fought in the Revolution, among them Captain James Scott and Ensign David Scott; many prominent Ridgefielders, including Judge Hiram K. Scott, who was town clerk for forty-six years; and Hezekiah "Uncle Kiah" Scott, a "distiller of spirits" and miller for whom Kiah's Brook is named.

The Barracks on the Hill

A lofty road at the edge of the Scotland District has an unusual history, recalling a part that Ridgefield—and France—played in the Revolution. Barrack Hill Road was named for the cavalry barracks built for members of Colonel Charles Armand's Partisan Legion of French troops, who spent time in Ridgefield in the Revolutionary War.

More formally known as Charles Armand Tuffin, Marquis de la Rouerie, Colonel Armand was a wealthy French nobleman who fought with the colonists. In the summer of 1779, Armand established a barracks for his Partisan Legion near the intersection of Barrack Hill Road and Old West Mountain Road. From there, his men went on sorties into Westchester and Putnam Counties, attacking the British and protecting Patriots. Some of his cavalrymen also acted as a sort of police force, patrolling the area to apprehend marauders, deserters, rioters, stragglers and other soldiers found guilty of violating the General Orders.

Ridgefield historian Silvio Bedini says the barracks were used for about a year. Armand then headed south, serving with Johann von Robais, Baron de Kalb, in North Carolina and finally participating in the surrender of the British at Yorktown. In 1783, Congress appointed Armand a brigadier general, indicating his service to the country was much appreciated. He had also become a friend of General George Washington, and the two corresponded for some time afterward.

On his return to France, Colonel Armand became involved in the revolution there, initially supporting the revolutionaries and winding up in the Bastille for a while. However, as attacks on the aristocracy

increased, he began defending the monarchy and eventually became an outlaw from the revolutionary government. He died of pneumonia in January 1793, just after learning of the death of King Louis XVI.

Although the structure is long gone, Ridgefield has recognized the existence of the barracks in a road name since at least 1857, when its first recorded use—spelled Barac Hill Road—occurs in a land deed. (The road may have earlier been known as "Toilsome Path," probably reflecting the rocky nature of the land in the area; it took a lot of work by the settlers to clear it for fields and pastures.) The colonel was recognized much later, in the names Armand Road and Armand Place at the Eleven Levels neighborhood, which was developed in the 1970s and '80s.

CARROLL'S FOLLY

A place name—or at least nickname—that at least one person was glad to see disappear was "Carroll's Folly." Leo Francis Carroll, perhaps the leading public servant in Ridgefield in the twentieth century, did not like the name at all.

Leo Carroll began a thirty-four-year career in the Connecticut State Police in 1919, when the department was largely a motorcycle patrol. The "Flying Squad," as it was called, mostly cracked down on trucks, many of which were hauling illegal booze. He rose through the ranks to become the lieutenant in command of Troop A Barracks in Ridgefield and later became second in command of the entire Connecticut State Police. Mr. Carroll then served four years as chairman of the state Liquor Control Commission.

In 1957, Mr. Carroll was elected Ridgefield's first selectman, a job he held for ten years. If that wasn't enough, in the 1970s, he served six years on the board of education. However, it was while he was running Troop A that the once well-known term "Carroll's Folly" was coined. According to Mr. Carroll, "some damn Democrat started it to hurt me politically."

Years ago, Routes 7 and 35 intersected with a ninety-degree junction, without a traffic light. It was a busy and dangerous intersection, and many accidents occurred. Around 1940, Lieutenant Carroll asked the state highway department to redesign the intersection to make it safer. The resulting semi-rotary arrangement lasted until around 1984, when the state returned the T, but this time with traffic lights.

The old traffic circle at Routes 7 (left) and 35 (upper right) around 1980 was known as "Carroll's Folly." *From the* Ridgefield Press *archives.*

Mr. Carroll once claimed that "the circle," as he preferred to call it, was "the safest intersection in New England. There hasn't been a single (serious) accident out there."

However, the seeming complexity of the circle gave rise to some complaints, many of them half in jest. One day soon after the intersection was completed, the Reverend Hugh Shields, pastor of the First Congregational Church, called Lieutenant Carroll at the barracks and said: "Lieutenant, I'm up here at 35 and 7, and I don't know which way to go to get to Danbury."

"Listen," Lieutenant Carroll replied, "you sober up, and you'll find your way."

The lieutenant, who knew the minister never touched a drop of alcohol, then hung up.

OLD STONES AND BONES

Like place names, even cemeteries can disappear, or at least their gravestones. Ridgefield's oldest cemetery, on Wilton Road East just south of the Main Street intersection, is marked with a monument reading: "Ye burying yard lay'd out ye Nov. 25, 1708 by the first settlers of the town of Ridgefield." The monument lists forty pioneers supposedly buried there, as well as "an unknown British soldier killed at the Battle of Ridgefield." The Village Improvement Committee of the Ridgefield Garden Club erected the stone list in 1931 after vandals, thieves and the elements had destroyed most of the old gravestones.

When he was writing his *History of Ridgefield* in the 1920s, George L. Rockwell found only two tombstones still standing there. By 1973, nothing remained except a small portion of a slate stone belonging to the grave of Captain Matthew Benedict, "who departed this life July 7, 1757." By 2001, that stone was not visible.

The cemetery originally extended across Wilton Road East and included what are now several lots holding houses on Main Street and Wilton Road East. Rockwell said the current burying ground "is only a portion of the original cemetery, as a road was cut through a section… about 1850, and the tombstones and remains of the early settlers were carted off. The town in town meeting sanctioned this deed."

Glenna Welsh, author of *The Proprietors of Ridgefield*, later observed: "Mr. Rockwell's curt closing remark infers that this action should never have been taken, as indeed, it should not."

It is not clear where the stones and bones were "carted off" to, but the earliest visible gravestones at the next oldest cemetery, Titicus, are dated in the 1730s.

Over the years, the burying ground had not always been well kept, a fact that would have made the old Village Improvement Committee shudder. In 1973, several trees had fallen across the rarely mowed grass and were left to rot. In 1988, local garden clubs cleaned up the property, but by 2001, the cemetery was overgrown, with trash dumped along its perimeter. In recent years, however, garden club members and the town's Cemetery Committee have kept an eye on the place, preventing it from being overrun. A park bench was even installed so visitors can rest while contemplating the town's founders.

How did the Village Improvement Committee know who was buried there? Perhaps from looking at the town hall's death records, which,

though they do not specify where burials took place, do tell the death dates. Anyone who died before Titicus was established in 1735 was probably buried at Ye Burying Yard, although some—like Captain Benedict—were buried after Titicus had opened.

THE RIDGE THAT'S HIGH

Many places in the village bear simple but ancient names. High Ridge, for instance, is a very old name. The earliest map of the village, drawn by town clerk John Copp in 1710 to show plow land lots, labels the elevation west of the main street as "ye High Ridge." For the first century and a half, this was where some villagers grew crops.

The name "High Ridge Road" first appears on the land records in 1833. Pre-1875 deed references always say "road," never "avenue," as modern maps label it. (If road and avenue are not enough, the 1867 Beers atlas called it High Ridge Street.)

The "avenue" reflects the changing history of the neighborhood. The word is French, referring to a tree-lined approach to a country house. It was not used in this country until Washington, D.C., was laid out in 1792. That inspired New York City to name major north–south roads "avenues" when Midtown and Uptown Manhattan were laid out in 1811. The word arrived in Ridgefield in the 1870s, around the same time that High Ridge and its road began to be marketed to wealthy New Yorkers as desirable sites for their summer and weekend retreats.

Describing High Ridge in 1878, the Reverend Daniel W. Teller wrote in *The History of Ridgefield*: "J. Howard King Esq. of Albany has…remodeled and greatly improved his summer home…He has also purchased the property on High Ridge and is greatly improving it. The street has been widened and adorned with young shade trees, in the same manner as Prospect Avenue, rustic gateways put up, and a pleasant observatory erected on the very top of the hill."

Notice that "avenue" was also being applied to today's Prospect Street back then. The aim, no doubt, was to give a touch of class and sophistication to the farmland that was being promoted to the New Yorkers. (Mr. King and his friends could have also gone for "boulevard," another French word for tree-lined streets that was gaining popularity in upper-class city neighborhoods.) Today, High Ridge is no more tree

High Ridge, looking south from King Lane, when the sidewalk—now removed—was almost as prominent as the road. That's publisher E.P. Dutton's house at right. *Postcard circa 1915 from the author's collection.*

lined than most other roads in town. To be historically accurate, its name probably should be returned to High Ridge Road, but that's not likely to happen.

King's efforts were successful, and among the people who had homes on High Ridge were book publisher E.P. Dutton, Charles Holt of the Henry Holt book publishing family and Charles A. Hamilton, president of International Silver.

How high is High Ridge? According to the United States Geological survey, the top of the ridge reaches 860 feet above sea level (at about where 55 High Ridge is situated). Round Pond up on West Mountain is only 778 feet (but at its highest point near Camp Catoonah at the end of Oreneca Road, West Mountain reaches 1,000 feet). Main Street at the town hall is about 735 feet, and East Ridge at its highest points (at the old high school and at the Ridgefield Skating Center) is only 750 feet.

Incidentally, the highest point in town is said to be Pine Mountain, which is at least 1,010 feet above sea level; George L. Rockwell maintained it was 1,040.

A Town That Isn't a Town

Some names are just plain confusing. In the case of Georgetown, people are always wondering what it is. Georgetown is a lot of things but not a town. Officially, anyway.

Connecticut has 169 official towns, each with its own government, such as a school board, zoning and police. Georgetown has none of those services.

Georgetown is a telephone exchange (544), a post office zip code (06829), a fire tax district, a former school district and a "census-designated place." It's part of three "real" towns—Redding, Weston and Wilton—and, some argue, also part of Ridgefield. However, over the years, Ridgefielders in the southeast corner of town have steadfastly opposed being identified with Georgetown and instead consider themselves residents of the Branchville section of Ridgefield. In the 1950s, a vote was taken among them on whether to have their mail delivered by the nearby Georgetown Post Office (meaning they'd have a Georgetown mailing address) or the more distant Ridgefield Post Office. Ridgefield won, hands down.

Georgetown is along the Norwalk River where the valley widens a bit. The area attracted mills that used the river for water power. The biggest was the Gilbert and Bennett Manufacturing Company, which began in the 1820s by weaving sieves from hair and wound up producing screening and fencing from iron. In 2014, it's a collection of empty buildings awaiting conversion to a big business and condo complex.

Who was the George of the town? In 1764, George Abbott moved to what's now called Georgetown, built a gristmill and became a prominent citizen. According to Georgetown historian Wilbur F. Thompson, "Soon after the close of the War of the Revolution, the people living on the hillsides and along the valley of the Norwalk River held a Fourth of July celebration...At this time the localities around the valley were called by different names: Osborntown, Honeyhill, Burr's Hill, St. John's Corners, Sugar Hollow, Jack Street, etc. At this Fourth of July celebration, it was voted to give these localities one name. Someone suggested Georgetown after George Abbott, the popular miller. It was put to vote and Georgetown became the name of the hamlet."

Most of the village of Georgetown, as well as the wire mill, is in Redding, while the Route 7 section south of Branchville is in Wilton. These areas, as well as the northwest corner of Weston, are served by the Georgetown

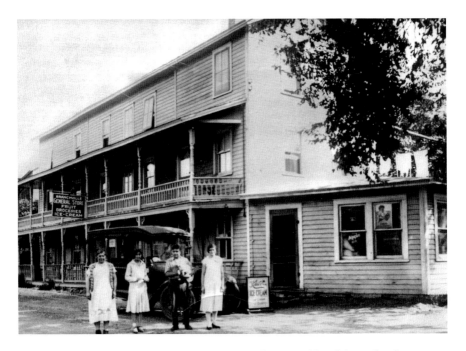

The DeBenigno family at their Branchville General Store considered themselves in "Branchville," not Georgetown, which was only a few feet away. The building was once a railroad inn; tracks are just to the left. *From the* Ridgefield Press *archives.*

Fire Department. They also have 544 phone numbers—as do people in Branchville. There is no longer mail service from Georgetown (except to post office boxes)—Weston, Wilton and West Redding Post Offices deliver to customers in their respective towns.

The Gilbert and Bennett School, built by the mill owners in 1915, once served up to three hundred Georgetown kids a year from Wilton, Redding and Weston; by special act of the legislature, it had its own three-town school district. (Branchvillians had Branchville schoolhouse on Old Branchville Road.) The school is now an arts center.

To the census bureau, Georgetown is a CDP ("census-designated place"), which means it has a concentration of population useful for statistical purposes. But it's still a town that's not.

THE OTHER "FOUNTAIN"

While names can be confusing, so can monuments. The Cass Gilbert Fountain at Main Street and West Lane, which is a Ridgefield landmark, functions in the warm months. But people wonder why they don't see water spouting from the "other fountain" on West Lane at Olmstead Lane. There are two reasons: it's not really a

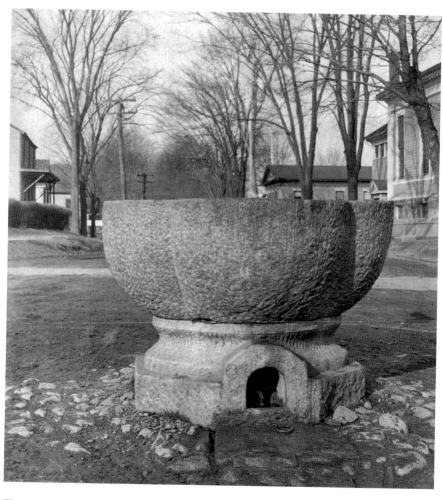

The watering trough stood in the middle of Main and Catoonah Streets. That's the firehouse roof in the distance and Methodist church at right. The opening at the bottom is for dogs. *From the* Ridgefield Press *archives.*

fountain, and its water-related value disappeared long ago. The stone fountain-like structure in the triangle of West and Olmstead Lanes is a watering trough.

Back in the pre-automobile era, when animals provided the main transportation power, the town often provided the horses and oxen with places to drink. Especially in summer, horses got hot and needed to drink fairly frequently as they traveled our often-hilly roads. The watering place could be as simple as access to a roadside stream, but other times it would be a tub or elongated trough—such as a large, hollowed-out log—by the edge of the road to hold water from a spring or brook. The Cass Gilbert Fountain at Main and West was actually designed to serve as a water source for horses as well as a decoration.

The Olmstead Lane trough was a gift to the town from John Ames Mitchell, a novelist and publisher who founded the original *Life* magazine and who lived on West Lane just beyond the schoolhouse. But back when it was new, the trough stood in the intersection of Catoonah and Main Streets, in front of the town hall. Its water was supplied by the public water system that had been installed in 1900.

Mitchell must have loved dogs because an unusual feature of the trough is an opening at the bottom, designed to provide wandering village pooches with a place to drink.

He donated the trough around 1910, just as the automobile was beginning to arrive on the scene, and within a decade or so, the trough was becoming a traffic hazard instead of a public service. In the fall of 1922, townspeople debated removing the trough. "This fountain is in effect a 'filling station' for horses," said B. Ogden Chisholm of High Ridge. "No thoughtful person would sanction a filling station for motor cars on the main highway." But Mrs. Cass Gilbert, widow of the "real" fountain's designer, said the trough should remain as a memorial to Mr. Mitchell.

Nonetheless, the trough was eventually moved to Titicus and then, in 1957, to its present location, where it serves largely as a giant flowerpot.

OUR OLDEST BUSINESSES

When it closed in early 2014, Ancona's Market in Branchville was by far the oldest business in town continuously operated by the same family. It

Ridgefield Hardware, shortly after it opened in its current location in 1948. The post office was next door then. *Postcard from the author's collection.*

had been founded ninety-three years earlier, in 1920, by Joseph Ancona (1890–1958). However, Ancona's Wines & Liquors, which did not close, is now the oldest—it was founded in 1933, when Prohibition was repealed, by the same family who owned the market.

The next oldest retailer is Ridgefield Hardware, founded in 1938 by Ed Rabin and operated in 2014 by his son, Jerry Rabin. Ridgefield Hardware started out on the east side of Main Street but in 1948 moved to its present quarters on the west side, a storefront that today looks the same as it did more than sixty-five years ago.

The oldest Ridgefield business is Bissell Pharmacy, which has been named "Bissell" since 1895, when H.P. Bissell bought Colonel Hiram K. Scott's store. However, Scott's store was already well established; it started in 1853 and sold not only drugs but also food and other wares and was the village post office.

Fairfield County Bank began in 1871 as Ridgefield Savings Bank; its first office was in a store that's now the Aldrich Contemporary Art Museum's office building (see page 98). The *Ridgefield Press* was founded four years later (it's been in the same family since 1937).

Ridgefield Supply Co. dates at least to the late 1880s, when Richard Osborn and William Gilbert opened in the present location (however,

Gasoline used to be sold in the village. Central Garage, at right, was where Bissell House restaurant is now. The old Bissell Pharmacy is beyond the Fisk tire and Exide battery signs. *Postcard circa 1930 from the author's collection.*

they'd had an earlier lumberyard in Branchville). It got the Ridgefield Supply name in 1933. The current owners, the Price family, acquired the business in the 1950s.

Craig's Fine Jewelry began on July 3, 1911, as Francis D. Martin's jewelry shop, near where Planet Pizza is on Main Street. The Craig family is only the second owner in more than a century.

Bernard's probably qualifies as the oldest restaurant. It began as the Kane Inn in the late 1930s, had become the Inn at Ridgefield by the 1950s and has been Bernard's since March 2000. While Kane Inn offered accommodations as well as food, Bernard's is solely a restaurant. (We say Bernard's is "probably" the oldest because a pub that was a predecessor of the Hideaway on Grove Street may have opened earlier.)

Stonehenge Inn is the town's oldest restaurant with the same name, having been founded in 1946 by Victor Gilbert, a young soldier returning from World War II, during which he was stationed on the Salisbury Plain in England.

The oldest "market" is now the West Lane Deli, which began as Casa-More (Casagrande and Moore were the owners) in 1940. While today more of a convenience store than a full food market, it still maintains the flavor of the old Casa-More.

Other oldies include Fairfield County Bank Insurance Services, which is the modern version of A.J. Carnall Insurance, founded in 1928, and

Ridgefield News and Office Supply, also called Squash's, which dates to the 1920s, when it was United Cigar Store.

Pamby Motors is the oldest auto dealership, founded in 1948. Pamby's gas station at Danbury Road and Grove Street may be the oldest continuously operated station in town, though we couldn't find when it was established. The Mobil station on Danbury Road is on the site of an early gas station, KEB (Keeler, Elliott and Brown, owners), which was operating in the 1930s. These would not have been the first gas stations in town, however; at least three businesses on Main Street had gas pumps in the 1920s, perhaps the late 1910s, and Shornick's gas station on Route 7 north of Branchville was also operating in the 1920s. The Shornick building still stands but is now an auto garage— without gasoline.

PART IV

THE WAY WE WERE

A look at some of the lesser-known ways Ridgefield people lived in the past and how they handled the good times and bad.

A HOT TIME IN THE OLD TOWN

One of the more unusual names found in our land records is "Peespunk," which appears only in very early deeds and may reveal an aspect of American Indian life in what is now Ridgefield that was not previously noted by local historians.

The term first shows up in a 1712 deed for land at "Peespunk Spring." Another deed from around 1717 mentions "ye Peespunk Brook." The reference suggests that the brook was near "Tackora's House." Tackora, an Indian leader, had an "old house" on the Titicus River near the New York state line, according to one of the settlers' deeds from the Indians. These and other deeds make it clear that the Peespunk Brook and Spring were around what is now the New York line in the Titicus Valley, possibly along the west side of North Salem Road.

Eventually, deeds simply referred to land "at Peespunk," suggesting that the locality was so well known that it became the name of a neighborhood—like Farmingville or Limestone.

Also spelled Peace Punk, Pesuponck and Pissepunk in other parts of southern New England, the word comes from "pesuppau-og," meaning "they are sweating." It appears in the languages of the Narragansett and the Paugusett tribes; the latter lived in Fairfield County.

A peespunk or "sweat lodge" was a hut or a cave where men built hot fires and took ceremonial sweat baths. Roger Williams, leader of the settlers of Rhode Island, described such sweathouses where the Indian men went "first to cleanse their skin, secondly to purge their bodies...I have seen them run (summer and winter) into brooks to cool them without the least hurt."

"This hot house," said Jonathan Trumbull in his *Indian Names in Connecticut* (1881), "is a kind of little cell or cave, six or eight feet over, made in the side of a hill, commonly by some rivulet or brook; into this frequently the men enter after they have exceedingly heated it with store of wood, laid upon an heap of stones in the middle. A lot at Indian Hill in Portland (Conn.) is called Hot House Lot, because it had one of these...and a swamp opposite Saybrook Point in Lyme is called Hothouse Swamp for the same circumstance."

Thus, long before the Finnish custom had become a fad in North America, our American Indians were enjoying saunas.

LIVING IN THE POORHOUSE

Long before someone coined the word "workfare," Ridgefield was practicing it. The Town Farm was the chief system of handling the homeless and indigent for more than seventy years.

In Ridgefield's early days, life centered on the family, and families saw to it that their less fortunate members were cared for. By the mid-1800s, however, more families had begun to split up as the younger members moved west. The number of homeless poor, mostly older men and women, began to increase. By 1872, voters asked the selectmen to investigate "buying or leasing a small farm for a residence for the town poor."

After much study of what other towns did, voters decided to pay up to $4,500 for "the Reed Farm in Scotland District," including a house, two barns and fifty acres. The house, still standing along North Salem Road at Circle Drive, was built in the early 1700s by the Scott family, from whom

Today, the old poorhouse looks like a colonial home—which is how it started out before becoming the residence at the Town Farm. *From the author's collection.*

that neighborhood (Scott's Ridge) and the school district (Scotland) took their names (see page 69).

The Town Farm gave the poor a place to live and a job to do. While townspeople may once have hoped that it would be self-supporting, it probably never was. The 1900 Annual Town Meeting appropriated $1,000 for running the farm; the amount rose to $1,200 in 1902.

By 1934, the Town Farm cost $2,787 to operate, mostly the salary of Mrs. Fred Young, the matron. That year, the farm sold produce worth $791 and also traded $101 worth of produce for merchandise and $63 worth for labor. The six "inmates" raised oats, hay, onions, mangels (a large beet fed to cows), turnips, carrots, corn, cabbages and potatoes.

In 1934, the farm was the town's third most valuable property, behind the East Ridge School and the town hall; it was worth $20,000, a sizable sum.

Living there was no "fun and games." Among the rules adopted in 1900 were:

• All inmates must be in their rooms by 9 o'clock p.m. and must be ready for breakfast in the morning at such time as the Matron may designate.

• Inmates will not be allowed in any room but their own room without permission from the Superintendent or Matron.

• No inmate will be allowed to be absent from the Alms House or to leave the Town Farm without the consent of the Superintendent or Matron, and any inmate leaving without such consent will not be re-admitted except by order of the Board of Select Men.

• No person or inmate will be permitted to bring any intoxicating liquors on the premises and no person or inmate will be allowed on the premises while intoxicated. No profane or indecent languages will be permitted.

• All packages for inmates shall be inspected by the Superintendent or Matron before delivery.

Harry E. Hull, selectman and first selectman in the 1940s and 1950s, recalled annual visits to the facility. "When I was on the board with [First Selectman] Win Rockwell, we used to go there every year and catalogue the apples and potatoes" and other produce, Mr. Hull said.

Mrs. Young continued to operate the Town Farm into the 1940s, when the number of inmates declined to the point where the town closed the operation and sold the property. Today, the "Alms House" is a private home, which is how it started out, and most of the rest of the farm is the Circle Drive subdivision.

FACTORY TOWN

While farming was the main occupation in eighteenth- and nineteenth-century Ridgefield, the town has had many industries since its founding three hundred years ago. The first were the many little mills that ground grain and sawed wood. Later, there were woolen and plaster mills, not to mention the cider mills that produced the local alcoholic beverages.

These appeared all over town; the only requirement was a good source of running water for power. A cluster of little water-dependent industries was in operation throughout the nineteenth century along Saw Mill Hill Road at Titicus; they included a cider mill, a sawmill, a flour mill, a tannery, a sash and blind factory and a blacksmith shop. In the late

The Big Shop in the early 1970s, after being condemned as a tenement. It's now restaurants, shops and offices. *From the author's collection.*

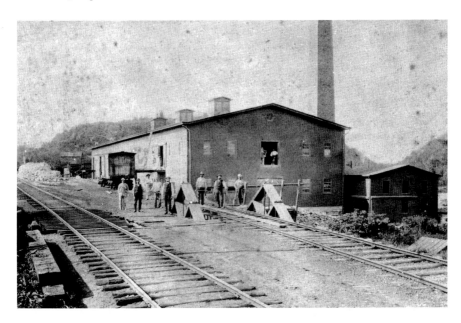

The silex mill in Branchville, just north of the station, in the late 1890s. The mill probably spewed some pretty ugly smoke in its day. *From the* Ridgefield Press *archives.*

1700s, an iron foundry existed just north of the Town Farm, smelting ore that may have been mined in nearby Ridgebury.

The first large "factory" was probably the Big Shop, built around 1830 on the site of the present First Congregational Church. It housed a carriage factory and other small industries. Top-quality carriages that were made there were sold as far away as New Orleans. To make way for the new church, the Big Shop was moved around 1888 to north of Bailey Avenue, where it served various uses, including a tenement. After it was condemned for residences in the 1970s, Bart Salerno bought it and, with great care and at considerable expense, converted it to spaces for shops, restaurants and offices. In 2014, the Big Shop housed several businesses, including Luc's and TerraSole restaurants.

In the late 1800s, Branchville, with its railroad service, became Ridgefield's industrial district. The town's biggest factory was the Branchville Silex Mills, owned by the Bridgeport Wood Finishing Company. Here, quartz—basically, the same material as sand—was ground into a fine powder, called silex, that was used as a pigment or filler in paints and stains. The quartz was obtained from the nearby Branchville quarry and probably from more distant mining operations as well, arriving and departing by train. The silex buildings stood along the tracks north of the present train station. Some were also on the west side of today's Route 7 along the spur rail line by Florida Road.

The company produced Breinig's Lithogen Silicate Paint and Wheeler's Wood Filler, as well as many wood stains and dyes, dryers and japans. In 1917, Bridgeport Wood Finishing was acquired by E.I. duPont Nemours Company. The Branchville buildings were torn down long ago.

Branchville also housed Grumman Tool Works, which among other things made equipment for harvesting ice, such as iron tongs. Its building is now an auto repair garage.

In 1964–65, Benrus, the watch company, built a 200,000-square-foot complex on Route 7 south of Route 35. Benrus was undoubtedly the biggest industrial operation ever in town, employing eight hundred people. But made-in-America watches soon disappeared and, with them, Benrus. The buildings are now the Pond's Edge medical offices and warehouses.

Perhaps the longest-lived factory in town is Ullman Devices, just south of Ridgefield Ice Cream on Route 7. The company makes small tools that employ mirrors and magnets. The plant opened in 1959 and was still going strong in 2014.

A FRENZY OVER RAILROADS

Local industries—as well as local people—needed transportation, and by the mid-1800s, many began depending on the Iron Horse. The nineteenth century saw a frenzy of railroad building nationally, and Ridgefield was no exception. In 1852, the Danbury and Norwalk Rail Road began service but was barely "in" town—cutting through the very southeast corner, then called Beers Station and now called Branchville. This line still exists as a commuter railroad, and there's even talk of reopening the passenger section from Danbury to New Milford and farther north.

However, the line was five miles from the center of Ridgefield, not very convenient for access to the town's business and population center. So in 1867, the Ridgefield and New York Railroad Company was chartered to build a line that would link the center of town with New York City. A station at Titicus, just north of the village, was planned, and the line would run through Lewisboro, Pound Ridge, New Canaan or Stamford and Greenwich, connecting with the New York and New Haven Railroad main line in either Stamford or Greenwich. There was also a plan for the line to continue north from Titicus to Danbury.

Seeing the threat from the upstart railroad, the Danbury and Norwalk Rail Road, at great expense, ran a branch line from Beers Station to the center of town in 1870 (and Beers Station soon became "Branchville"). While the proposed new Ridgefield and New York Railroad's route to New York City would be shorter and faster than riding to Branchville and Norwalk, then to New York, it would be expensive to build. Nonetheless, stock was sold, and in the 1870s, work actually began on the rail bed. The bed is still visible today. The best place to see it is at the north end of Golf Lane as the line crosses Peaceable Street and then Golf Lane; on the west side of Golf Lane, it is now the raised base of a driveway leading to three houses.

Having trouble raising cash to complete the job, the Ridgefield and New York began asking the General Assembly for extensions of its charter. As late as 1886, there were still plans to complete the road, but they never panned out.

Also in the 1860s, there was talk by the New York and Northern Railroad of running a line from Danbury to New York City that would pass through Ridgebury. The upper part of that line, never completed, was taken over by the "Danbury and Harlem Traction Company." In 1903, the company got permission to operate an electric trolley from Danbury to Ridgebury.

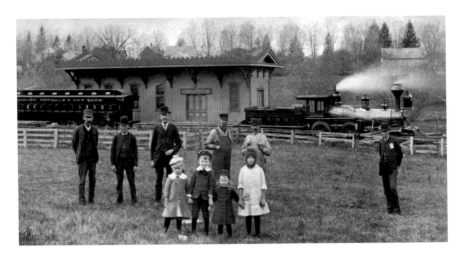

An unidentified group stood just west of the Ridgefield station in the 1870s. The building is now part of the Ridgefield Supply Co. complex. *From the* Ridgefield Press *archives.*

That service opened soon thereafter but did not last long—how many passengers could they have had to and from rural Ridgebury?

This line may still be seen along George Washington Highway and forms the bed of Old Trolley Road. Its continuation toward New York City traveled down the middle of Ridgebury Road for about a third of a mile, to the Benson Road area, where it headed southwesterly through the Ridgefield Golf Course and into North Salem just north of Chestnut Hill Road—you can see it just across the New York line on Finch Road. It's also visible in various places in North Salem center, along Route 116 and especially along upper Route 121.

A DIFFICULT OPERATION

The four-mile line from Branchville to the village of Ridgefield was a challenging and probably unprofitable enterprise of the Danbury and Norwalk Rail Road. The company's first venture, the line from Norwalk to Danbury opened in 1852, was very successful. By 1870, the company was issuing stock dividends of 16 percent.

Started in 1869 and opened June 25, 1870, the branch line was clearly designed to beat the competing railroad that was planning to serve

A ticket for a train trip between Branchville and Ridgefield, sometime before 1925, when passenger service ended. *From the* Ridgefield Press *archives.*

Ridgefield center from the southwest and the north. But the Ridgefield branch was a financial and physical challenge. While the main line had been fairly easy to build, following the mostly gentle elevations along the Norwalk River and Simpaug Brook, Ridgefield center was atop a ridge. The elevation at Branchville is 342 feet above sea level, while up in the village, it is more than 700 feet. That grade of up to 120 feet per mile was "one of the most difficult operations in the state," said L. Peter Cornwall in *In the Shore Line's Shadow*, a history of the Danbury and Norwalk Rail Road. Construction cost about $250,000 ($4.2 million in today's dollars), which was "as much as the entire main line had cost 19 years earlier," Mr. Cornwall wrote. This, to serve the center of a town that had only 1,900 people. But it did apparently succeed in keeping out the competition.

For many years, the line had three trips a day. Each train included a passenger coach, a mail car and whatever number of freight cars might be needed to bring such things as coal and lumber to town. The engine was at the head coming up the line and remained there as the train backed down to Branchville. The trip up the line took at least fifteen minutes, while returning—without even using the engine's power other than to brake—took ten.

Along the way, there were little shelters at Cooper Road and Florida Road where passengers could flag down a ride. (In the early 1900s, these might be students going to school in the center.)

Both Branchville and Ridgefield stations still exist; Ridgefield Station is now a building at Ridgefield Supply Co. on Prospect Street.

The automobile and the truck spelled doom for the costly branch line. The last passenger service was in 1925. Freight service continued

until February 1964—probably the last customer was Ridgefield Supply, which got its lumber by rail. But trucks by then were cheaper and probably faster transportation. The rails were soon removed, and the bed remained empty until the 1970s, when CL&P acquired most of it to run a high-voltage transmission line into town. Only three of the four miles are CL&P's—private owners bought most of the bed between where it meets Florida Road and Branchville Station.

Today, the CL&P bed is also a rail trail, limited to pedestrians (though a vote was due to be taken in 2014 on allowing bicycles).

THE WRECK OF THE 8:20

The branch line was the scene of a horrible accident in the early twentieth century.

The 8:20 a.m. train left the Ridgefield station on April 17, 1905, heading southeast down the tracks to Branchville. In less than a mile, something went wrong. The tender broke away from the engine. Moments later, the tender and engine collided, causing the engine to jump the tracks and roll over. The engineer was killed.

"Old railroad men said it was the worst wreck they had ever seen," reported the April 20, 1905 *Ridgefield Press*.

The 8:20 that day carried two cars, fairly loaded with people going to work. April 17 was a Monday, a busier than usual day because many passengers worked in New York City, often staying there during the week and spending only weekends here. On this Monday, soon after the train passed over Ivy Hill Road, the engine and tender became disconnected. The engine rammed the tender twice, both jumped the tracks and rode the ties for a short distance and then they rolled over. The engine slid a short distance down a hill.

Pinned under the cab, engineer William Horan of Danbury was scalded by steam spewing from broken pipes. At first, the clouds of steam prevented rescuers from reaching him. After the steam died down, workers had to dig away at the ground under Horan to remove him. "He was conscious while they were working to get him released, and called for his wife," the *Press* reported. "He suffered intensely and lived only a few minutes after being taken into the baggage car."

The first to reach him was conductor George W. Weir. A letter to the *Press* that week proclaimed Mr. Weir a hero. "He rushed through

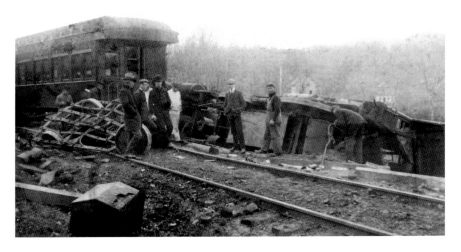

The engineer was killed when his engine went off the tracks and down an embankment. *Courtesy of Ridgefield Historical Society.*

the escaping steam," said the unnamed writer, "fearless of death from scalding and the falling debris of the wrecked engine, and pushed off the hot iron and timber as well as he could from the imprisoned engineer. It was a brave act and there were few there to see it. All the heroes in this world do not wear epaulettes on the battlefield. There is a hero right here in Ridgefield."

News of the wreck quickly reached town. Joseph Coffey, only four years old at the time, recollected seventy years later that someone ran to his father's house a couple of hundred feet from the wreck. The man asked to borrow the Coffeys' horse to ride to town for Dr. H.P. Mansfield. Pastor Richard Shortell of Saint Mary's Church was also summoned and arrived in time to administer the last rites before Mr. Horan died.

First reports of the accident said Horan had been killed and fireman Thomas Dwyer was dying. "The latter part of the story fortunately proved untrue, but the melancholy fact of Mr. Horan's death was, alas, too true," the *Press* said.

Fireman Dwyer later told a reporter, "When the tender ran off the track, I heard Horan, the engineer, say something I could not understand. He shouted excitedly and at the same time, shut off the power and reversed. The engine then toppled over and all the steam pipes seemed to burst. As the engine went over, I found myself in the cab surrounded by a cloud of steam and felt something holding me down. The wind was

blowing at the time and suddenly it blew the steam from the cab so I could see the window. I do not know what it was that held me down, but I managed to tear myself loose and climb out the window. Reaching the open air, I ran down an embankment in my confusion and brought up against a stone wall."

Dyer said, "I do not know what caused the accident and probably no one ever will. The rails were new ones and heavy ones, but the tender had a heavy load of coal on it, and it does not seem possible that the reversed position of the locomotive could have caused it to leave the rails."

Almost philosophically, the fireman added: "It was an accident and I suppose there will be accidents as long as there are railroads."

Oddly enough, Mr. Horan had "one of the best records" with the railroad and a reputation for avoiding accidents. "He had been on important runs for many years and had distinguished himself a number of times by his presence of mind under trying circumstances," the *Press* said. For instance, four years earlier at Brookfield Junction, Horan had stopped his train to await the arrival of the southbound Pittsfield Express—in those days, the passenger service went from Norwalk to western Massachusetts. "When the Express arrived, an air brake failed and the train had difficulty stopping. Horan, seeing this, started his train down the track. Although it was struck by the Express, it was saved from any serious damage," the *Press* said. Ironically, the engineer who took over the Brookfield run from Mr. Horan died in a wreck a week before Mr. Horan's death.

None of the Ridgefield passengers was injured. Arrangements were made to transport them to Branchville, along with the mail.

Repairs to the tracks began immediately. "The track and ties for several feet in either direction was torn up and twisted as though an earthquake had disturbed it," the *Press* reported. "The engine cab was completely demolished and the whistle, bell and other appurtenances were torn off and scattered along the track."

More than thirty-five men spent several hours repairing damage and putting the passenger cars back on the track. "The ease with which the large steam derrick lifted cars and the tender and would swing them around like toys was a wonderful sight," reported an eyewitness. Work was completed in time for the 6:00 p.m. train from Branchville to roll through.

Many people visited the crash scene that day and the rest of the week. The engine remained alongside the tracks until Sunday, when heavier-duty cranes arrived.

Mr. and Mrs. Dennis Coffey probably spent most of the day assisting workers and visitors. In a 1975 interview, son Joseph, the eleventh of thirteen children, would remember the occasion only dimly. "My mother was dressing me when it went off the track," said Mr. Coffey, who died in 1979. "I can still remember standing on the chair, looking out the window at the train."

WHEN SNOW WAS GREAT FOR ROADS

Ordinary roads were, of course, always the main paths for transportation. Their chief shortcoming was water related: rain would wash out sections of roadway and would turn many stretches into vast ribbons of mud. However, all precipitation was not bad. In the old days, snow was a boon, not a bane.

In the nineteenth century, roads were not plowed to remove snow because snow generally improved the condition of the surface. It was usually easier to slide a sleigh or sledge over snow than roll wheels through mud or even over hard ruts. If temperatures remained cold, the more a road was used, the more packed down and harder the snowy surface became.

A horse could drag four times more weight on a sled across snow than it could on a wheeled cart over dirt. Sleds, sledges, sleighs and especially "stone-boats"—a specialized, heavy-duty sled—made carrying heavy loads over snow easier than any other method of local transportation. In many areas, snow was so prized for its surfacing characteristics that main roads were rolled to pack and preserve the snow coating. The community roller was like a giant wooden barrel, with a driver on top and a team of horses to pull it. In some places—such as on the floors of covered bridges—the snow was "imported" to cover the surfaces so that the runners would not drag over wood.

Even off roads, snow was useful. It allowed farmers to easily haul timber home from the woods to cut for firewood, to saw into lumber or even to hew into railroad ties (see page 137). Snow meant that "stone-boats" could remove large boulders from fields and that other heavy-duty tasks could be accomplished.

Incidentally, wood was gathered in winter for a couple of reasons besides the slick surface. First and foremost, farmers had the time—there were no crops that needed tending. In addition, the winter woodlands

Dave Dougherty of the Lynch estate on West Mountain drove down Main Street with a two-horse team pulling a Russian sleigh after a storm in the early 1930s. *From the* Ridgefield Press *archives.*

lacked the thick underbrush that made movement among the trees difficult. Trees in winter were also easier to cut since the sap was not running and the limbs were not loaded with leaves.

Of course, a big problem with snow is that it melts. Thaws created slushy, muddy messes on dirt roads—and still do, as anyone who has dealt with "mud season" in Vermont knows.

THE RISE OF OLD HUNDRED

Roads and how people use them have changed in the past century. So has our treatment of buildings. Today, older houses are often torn down to make way for new houses. In the past, however, people would value the worth of most buildings much more than they do today—not necessarily in dollars but in intrinsic value. It was not a matter of its being a shame to tear down an old building; rather, it was a waste to do so.

Most old buildings were built to last. Structural timbers were fashioned from hardwood trees that had been growing for centuries, not from softwood pine and fir a generation old. Floors were American chestnut, oak or other good wood.

Old Hundred as it appeared before 1884 when it was still a one-story store. *From the* Ridgefield Press *archives.*

When it came time for a new owner or a new use, old buildings might be added to or subtracted from—even doubled. One fine Main Street home was cut in half and turned into two houses (see page 130).

An unusual example of the old-time respect for quality is found in Old Hundred. Built around 1783 on Main Street, the one-story structure served as the general store of Lieutenant Joshua King and his partner, Lieutenant James Dole, both veterans of the Revolution. It stood on the east side of Main Street, opposite Lieutenant King's house on the corner of Main Street and King Lane. The building supposedly picked up the name Old Hundred because it was used as a store for a full century.

In 1871, the Ridgefield Savings Bank—which has now burgeoned into Fairfield County Bank—had its first office in this little building, capitalizing on a center of local commerce to become a center of local finance. It was also the town's first official post office; Lieutenant King became the first postmaster in Ridgefield.

In 1867, D. Smith Gage bought the business, and in 1884, he moved the operation north on Main Street to the corner of Bailey Avenue (where it was later the source of the Great Fire of 1895—see page 61). The Old Hundred property was sold for a home. By late nineteenth-

Old Hundred in the 1960s. A second floor was added as a first floor about 1884. *From the* Ridgefield Press *archives.*

century standards, the building was a bit small for a house. But instead of tearing it down, the owner—we don't know who—decided to expand. He didn't add wings to the building, however; he added a second floor. But the second floor was actually the first floor. Rather than replace the nice gambrel roof that the store had possessed, the owner decided to raise it and the rooms underneath. Old Hundred became the top floor, and a new first floor was added. It must have been quite a sight to see—Old Hundred being slowly jacked up and a new story being built beneath.

The two-story building remained a house until 1929, when it was acquired by the First Church of Christ, Scientist and used as a church and meeting place. In 1964, Larry Aldrich purchased it to create the Aldrich Contemporary Art Museum. The art has since moved to a new building in the rear, and Old Hundred is now administrative offices for the

museum. Today, the recently refurbished building still stands prominently on Main Street—with hardly anyone realizing that its second floor was an eighteenth-century store that once had its feet firmly on the ground.

POST OFFICES, ROOTED AND ROLLING

Old Hundred was said to be the town's first official post office. Therein is another example of changing times.

For years, people have complained about the current Ridgefield Post Office and its lack of convenient parking spaces. Long ago, parking was never a problem when visiting the post office—the town had a fraction of today's population and seven times more post offices.

From the nineteenth century into the twentieth, almost every major section of Ridgefield had its own post office.

There was, of course, a center post office, located in a variety of places over the years. The new nation's federal post office system was established in 1791. The first official Ridgefield center post office opened two years later in the King and Dole Store ("Old Hundred"); before that, privately handled mail came to the Keeler Tavern.

Ridgebury's post office was in a store that stood just north of the congregational church—see picture on page 124. Limestone's post office was located in a house near Stonehenge Inn while Scotland's was in a home on North Salem Road nearly opposite Pond Road. Though it was only a short distance north of the main village of Ridgefield, Titicus had a post office for many years, located in the Titicus Store. The old store building still stands at the southeast corner of North Salem Road and Mapleshade Road and is now used as an office.

Silvio Bedini, in his *Ridgefield in Review*, reports that a post office existed along the train line between Ridgefield center and Branchville. It was supposedly located at Cooper Station, hardly more than a shack, on Cooper Hill Road.

Branchville itself had a post office, too, right at the station. Trains were the main source of outside mail, and bags of incoming and outgoing mail were transferred at Branchville Station.

The neighborhood post offices were closed down early in the twentieth century when the automobile began to make travel to the center post office and delivery of mail much easier.

An envelope mailed in 1896 from the old Titicus Post Office. *From the author's collection.*

This Ridgefield postcard was mailed on a railway post office, probably stopped at Branchville Station, in 1906. *From the author's collection.*

One other post office deserves noting because it passed through Ridgefield. That's right, *passed through.*

In the last half of the nineteenth century and first part of the twentieth century, many trains on the line from Norwalk up to Pittsfield, Massachusetts, carried mail cars that were mobile post offices. Mail was cancelled and sorted as the train was moving along the tracks. While passengers could not access the "railway post office" car, people on station platforms could. Most postal cars had a special slot through which mail could be deposited, and many people used this service because it was faster than a traditional fixed post office; overnight delivery was more likely.

Railway post offices employed special postmarks, saying "RPO" and including the names of the towns at both ends of the line on which the post office car was running. Letters mailed from Branchville generally were cancelled Danbury and South Norwalk.

WHEN EVERYONE KNEW THE POSTMASTER

While each little neighborhood post office had its own postmaster, the postmaster of the main post office in the village was considered the most important and prestigious postal post in town. For two centuries, that job of town postmaster was always given to a Ridgefield resident—that's the way the Post Office Department worked for most of its lifetime. The postmaster didn't really have to know much about the mail system, but he or she did have to have some management skills and, often, some political connections.

There were twenty-eight Ridgefield-resident postmasters between 1793 and 1982, when the last of them, Richard E. Venus, retired. Since then, all postmasters have been civil service employees, who have risen through the ranks—and who invariably live elsewhere.

There was an advantage to naming residents as postmasters—they knew their town and its people. And the people knew them. If there was a problem with the mail, the man in charge was easy to find and often worked hard to remedy the difficulty.

Mr. Venus once observed that his office was the closest to the people in town. "After all," he said, "we call at every house in town every day." And for many of his twenty years in office, the gregarious Dick Venus knew most of those customers personally.

THE FAIR THAT WAS MORE THAN FUN

Ridgefield has several church fairs, carnivals and such today, but the town once had a good, old-fashioned agricultural fair. But the event wasn't all fun and games and represented an important professional event in the lives of local farmers.

The annual Ridgefield Fair and Cattle Show, sponsored by the Ridgefield Agricultural Society, began in 1858 and lasted until 1881. The first fairgrounds—then for a one-day event—was on Gilbert Street. As the affair grew in popularity and size and lasted two days, it was moved to Governor Street at what is now Veterans Park. Finally it found permanent home at the "Fair Grounds" east of Wilton Road West, opposite Olmstead Lane. By then, probably at least 1865, it was a four-day event—Tuesday through Friday—and was large enough so that, one year, 112 yoke of oxen were exhibited.

"It seems almost impossible to realize at the present time that such a number could have been assembled," wrote historian George L. Rockwell in 1927, noting that when they lined up to parade into the fairgrounds, the oxen extended from just south of Branchville Road down Main Street and Wilton Road West to the entrance opposite Olmstead Lane.

The fair in late September or early October—it varied from year to year—was a typical country fair, with exhibits of products, produce and livestock, music, food and awards. An old awards list contains thirty-one categories for ribbons: field crops, grains, grass seed, vegetables, fruit, floriculture, bread, dairy, honey, preserved fruit, pickles, cakes, wines, ladies' industrials, fine arts, musical instruments, domestic products, farming utensils, poultry, sheep, swine, oxen, draught oxen, working oxen and steers, milch cows and heifers, thoroughbred stock, fatted cattle, stallions, colts, family horses and road horses.

Rockwell reported that one of the more unusual attractions one year was a very early "automobile," exhibited in the 1870s by a Stamford man named Simon Ingersoll. "The automobile may be described as being a large box set on small wheels, narrow gauge, and steam was the motive power," he said. "The machine was driven up and down Main Street, exciting much curiosity and wonder. At the Fair Grounds, it was speeded around the track."

The track, which appears in the 1867 Beers atlas of Fairfield County as a "race track," was designed for trotters. Remnants of the track were visible well into the 1950s.

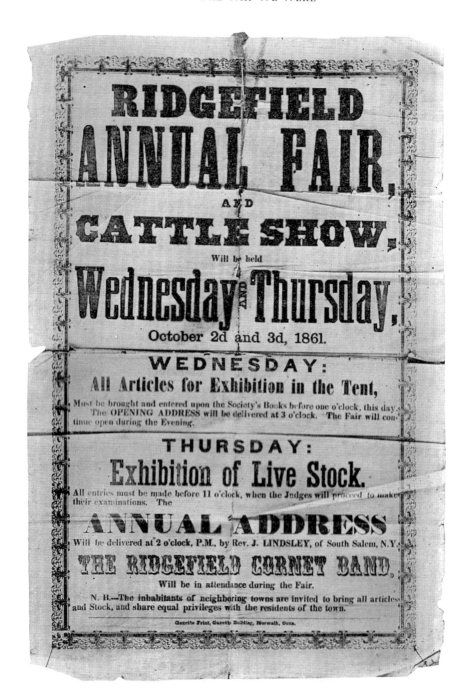

A poster from 1861, when the fair was still in the center of town and had not yet moved to the Fair Grounds on Wilton Road West. *From* History of Ridgefield *by George Rockwell.*

The Ridgefield Agricultural Society sponsored the annual fair. Perhaps the membership card included free admission to the fair. *From the author's collection.*

Lumber from the old fairgrounds exhibition building was used to construct Sperry's livery stable on Catoonah Street, shown circa 1915. The building collapsed in 1948. *Postcard from the author's collection.*

While such fairs were fun, they also functioned as agricultural "conventions." Farmers got to see the latest products—and mid-nineteenth-century agricultural markets were booming with new machines, tools and seed varieties. They could hear lectures on improved farming techniques.

Equally as important, they also got to chat with a wider group of farmers and could discuss and critique some of the modern-day advances. At a fair, "they saw, gathered up in a small compass, what was going on in the farmer's world, and this within a single day or two," said an 1860s book on farming. "Thus, they accumulated a fund of knowledge which they could not have acquired had they remained at home."

Jared Nash, a farmer who lived on Silver Spring Road and whose 1864–65 diary exists, reported his family went to the fair each year. He had no comment on the event, just the weather. But in her diary, Anna Marie Resseguie was more critical. She wrote under September 18 to 20, 1866: "Days of our annual Fair; rainy, small attendance, inferior display."

The fair ceased operation in 1881, possibly because of competition from the Danbury Fair (which operated for more than a century where the mall of the same name now stands). The Ridgefield fairgrounds had included a sizable exhibition building, which was dismantled after the fair closed. True to the Yankee spirit of not wasting, the lumber from the building was used to build the Sperry livery stable, which stood across from the firehouse on Catoonah Street. However, one might wonder about the quality of the wood or the design: the huge building collapsed from the weight of the snow on its roof after a storm in January 1948.

The Fair Grounds were historic before the fair. They had been the location of the British overnight encampment after the Battle of Ridgefield in 1777. Today, the land is occupied by homes on Wilton Road West and Soundview Road.

A DUFFER'S DELIGHT

Perhaps in a sign of changing times in Ridgefield, soon after the agricultural fair vanished, a golf course appeared—and not far away.

The Country Club of Ridgefield was among the earliest golf courses in the United States and was one of the first two in Fairfield County. Also called the Ridgefield Golf Club, a sixty-five-acre, nine-hole course

The main building of the Ridgefield Golf Club, shown around 1920. Note the boys on the porch, waiting for caddying jobs. *Postcard from the author's collection.*

was started in 1894—the same year the United States Golf Association was founded—and incorporated and completed in 1895. (The first courses in the country date from 1887 in Quogue, New York; Foxburg, Pennsylvania; and West Orange, New Jersey.)

The *Ridgefield Press* on August 2, 1895, said, "Probably the new Country Club will be ready for its members by the middle of September, judging from the activity of the building committee, and golf will then be as popular as in other watering places."

The *Press* was careful to point out how the project was affecting the local economy. "The bid of Contractor William Sunderland of Danbury, who built the Olcott country-seat (Casagmo mansion on Main Street), has been accepted and the mason work will be done by Hiram Davis & Company. The mason's material will be furnished by H.D. Keeler."

By 1901, *Harper's Official Golf Guide* reported that the club had an entrance fee—a share of stock—of $300 (about $7,000 in today's money). Annual dues were $25 ($580). The layout was: hole one, 324 yards; two, 196; three, 267; four, 178; five, 208; six, 282; seven, 310; eight, 245; and nine, 260.

Officers were George G. Haven Jr., president; George C. Shelton, MD, vice-president; and Albert H. Storer, secretary-treasurer. All were no doubt millionaires, and all—no surprise—lived within a mile of the course.

The club closed around 1932, the year the eighteen-hole Silver Spring Country Club course opened. Most of it later became Jack B. Ward's Ward Acres Farm, where show horses were raised, but in the 1980s and 1990s, much was subdivided and is today house lots along Peaceable Street, Golf Lane and Lewis Drive.

The clubhouse managed to survive until the early 1980s. Francis D. Martin had moved the building in the 1930s to Grove Street, where he used it as a goat barn. In the 1950s, it was incorporated into the scientific laboratories of the New England Institute for Medical Research. The financially troubled institute closed around 1982, and vandals burned the clubhouse portion. (The site is now the 90 Grove Street Executive Pavilion office condominiums.)

Golf Lane was so called as early as 1902. However, the road existed long before the course and is shown on the earliest road map of Ridgefield (1856). The road was probably in use as early as the 1700s as a shortcut from Peaceable Street to West Lane.

DOGS MUZZLED AND MAD

Dogs, probably the most popular pet in town today, haven't always been highly regarded here, but Ridgefield has had its share of canine heroes.

Among the earliest references to dogs in town records was in 1850, when complaints prompted officials to propose banning them from running loose and to charge an annual tax of twenty-five cents per dog to cover expenses of regulating them. Voters rejected the plan at a town meeting—they didn't like paying two bits to own a dog.

Roaming dogs were a problem because they might attack livestock, such as sheep. By 1878, a state law required that all dogs be muzzled. Any dog not muzzled could be "shot on sight," and the shooter paid $1 for his troubles, the *Ridgefield Press* told readers. Registration of dogs began in 1908. Untagged strays were impounded, and owners had to pay $5 (about $125 in today's dollars) to get them back.

Over the years, the *Press* carried reports of dog problems such as in July 1902, when a "mad dog" bit lawyer Sam Keeler, attacked several other dogs and children and killed a cat before A.W. Northrop grabbed a gun and "ended its career."

Dogs got good press, too. One night in June 1913, Burt Dingee, possibly a bit tipsy, was walking with his dog along the tracks in Branchville when he was struck by a northbound train. With the dog at his side, he lay helpless all night in the pouring rain. When the 6:00 a.m. train out of Danbury approached Branchville, the engineer spotted the dog standing in the middle of the tracks, barking at the locomotive. The dog refused to move. The engineer stopped the train, discovered Dingee and summoned medical help. Dingee recovered.

In May 1929, Joseph Thoma, sixty-three, his dog at his side, was driving his horse and carriage along Silver Spring Road when he had a heart attack and died. State police arrived, but the dog would not allow them to touch Mr. Thoma. They had to wait for his daughter to come and call the dog away. "Here again is an instance of the fidelity of man's friend, the dog," the *Press* said.

Dogs have suffered for their owners. In January 1973, Elfrieda Travostino, outspoken head of the Ridgefield teachers' union, told police someone entered her house, took her dog and hung it by the choke collar from a tree in her yard. A telephone caller said, "We have muzzled your dog. If you don't shut your loud mouth, your kids and you will be next." The dog survived, and there were no further incidents.

Even official dogs had problems. In April 1980, Brutus, the Ridgefield police dog, was stolen from the dog pound, where he was staying while his handler, Officer Donald Monckton, was away. "The dog is basically friendly, but is trained to become aggressive upon command," warned police. Brutus was found a month later wandering around Brewster, New York, after he had been abandoned by or had escaped from his dognapper.

PART V
MOSTLY MYSTERIES

Some questions about Ridgefield's past remain mysteries, and we can only guess at the answers, while other mysteries may be solved.

THE WAR MEMORIAL MYSTERY

For nearly a century, Ridgefield has unwittingly honored a man executed for treason by the United States Army. The traitor's name is displayed in bronze on Ridgefield's War Memorial along Main Street at the head of Branchville Road, but just how it got there is unclear.

The memorial to veterans was dedicated on July 4, 1925, with a large celebration that included a parade, bands and speeches. It was built after a fundraising campaign organized by the American Legion Post, founded five years earlier.

The monument was designed by architect and artist Laurence Peck, who lived on West Mountain just across the Ridgefield line in South Salem. A graduate of Harvard and the Beaux-Arts School in Paris, he was an accomplished artist whose work was exhibited by the National Academy of Design in New York City. During World War II, Peck was an executive with the War Production Board and active in civil defense. He worked at one of the more unusual war industries, the South Salem Studios, which designed miniature models used to train seamen and

The War Memorial on Main Street, shown around 1930, accidentally bears the name of a traitor. *Postcard from the author's collection.*

soldiers to recognize various ships and military aircraft. (Sets of the models today can fetch hundreds of dollars on the antiques market.)

The monument's bronze work was sculpted by Raffaelo E. Menconi, a native of Italy (whose son became a noted sculptor of medals, especially of United States presidents). Gorham, one of the nation's top founders, cast the plaques and built the monument in Providence, Rhode Island.

The monument bears the names in bronze of Ridgefield soldiers in all the wars through World War I. The names were apparently not extensively screened, however, for among the Civil War veterans listed is John Rowley, who was executed on September 3, 1864, for murder and treason. A court-martial in Petersburg, Virginia, convicted Rowley of deliberately shooting a comrade in the head during a battle in Florida. (Killing a fellow soldier, especially in wartime, was a treasonous act.) Rowley had gotten into a disagreement with the fellow soldier, reportedly over a woman.

How Rowley's name got on the plaque remains a mystery. He had been a British sailor, hired as a substitute for someone who wanted to avoid the draft. Neither he nor, apparently, the substitute was from Ridgefield, but Rowley was somehow mustered into the service from Ridgefield. Apparently, too, whoever prepared the list of names to include on the memorial did not see his record.

Archives at the Connecticut Historical Society relate an odd, connected story. Harriet Ward Foote Hawley took pity on Private Rowley and attempted to comfort him as he awaited hanging—including bringing him a Bible. Mrs. Hawley believed Rowley had been a victim of having had no education or training, she wrote in an 1864 letter.

Her efforts may seem unusual, considering that her husband was a major general in the Union army that was executing Rowley. Joseph Roswell Hawley was one of Connecticut's leading citizens of the nineteenth century. He had been a journalist and newspaper editor who joined the army and served throughout the Civil War, rising from captain to major general. After the war, he was elected a congressman and, finally, for more than twenty years, served as a United States senator from Connecticut. He died in 1905, two weeks after retiring from the Senate.

FLORIDA IN RIDGEFIELD

Florida is a mystery among Ridgefield's old place names. The first mention in land records occurs in an 1827 deed for three acres "at a place called Florida," and later it became the name of a school district whose schoolhouse was at the corner of Florida Road and Florida Hill Road.

Historian George L. Rockwell said he'd tried unsuccessfully for forty years to figure out the source of the name.

However, here are some possibilities we've come up with:

• The United States in the early 1800s was shaped such that the north-to-south distance was greater than the east-to-west distance. So was Ridgefield, even more so then than today; at that time, the town extended all the way from Wilton to New Fairfield (see page 131). Florida District was situated in the southeast corner of Ridgefield (the Florida school district originally included Branchville), just as the territory of Florida was in the southeast corner of the United States. Some imaginative person may have found a name-worthy similarity there when the town was beginning to title school districts.

• Florida was ceded by the Spanish to the United States in 1819. It's possible someone thought this event significant and named the school district to commemorate it.

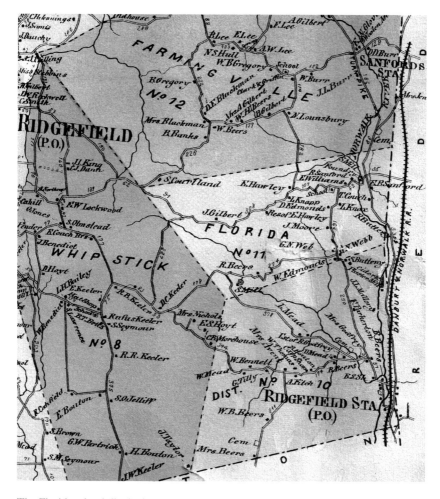

The Florida school district is shown on a Beers atlas map in 1867. Branchville was then called Ridgefield Station—the namesake "branch" hadn't been built yet. Earlier, it was Beers Station. *Map from the author's collection.*

• An area in New Canaan is called "Michigan," supposedly because two early New Canaanites moved to that state and later inherited some property in their old Connecticut neighborhood. That land came to be called the "Michigan Lots," and later the whole area around them became simply "Michigan." Maybe a similar episode happened here.

• The word "Florida" is derived from words meaning "flowers" and can mean "flowered" or "flowery." An unusual abundance of wildflowers,

such as mountain laurel, might have prompted someone with knowledge of Spanish to coin this name for the locality.

• "Florida," says George R. Stewart in his *American Place Names*, was "one of the exotics which were favored in the post-Revolutionary period" for place names in Massachusetts and other states. Thus, it may simply have been a "fad" name applied to this area so that it—like Farmingville, Ridgebury, Flat Rock, Scotland, etc.—would have a distinctive appellation of its own.

THE WOMAN WHO VANISHED

A one-time resident of the Florida District who had been a homemaker and mother became the center of one of New England's most publicized mysteries of the twentieth century.

Joan Risch and her husband, Martin, had lived off Florida Road and later on Rowland Lane in the 1950s and early '60s but moved to Lincoln, Massachusetts, early in 1961. On October 24, 1961, Mrs. Risch vanished from her home, leaving behind her husband and two children, ages four and two.

Police were summoned after the daughter came home from a neighbor's house and found her mother missing and the two-year-old asleep upstairs in a crib. "Mommy is gone, and the kitchen is covered with red paint," she told a neighbor.

A trail of blood led from the kitchen to the driveway, where a neighbor reported seeing Mrs. Risch, standing by her car, looking dazed. Mrs. Risch, who was thirty, was never seen again.

In the kitchen, police found the phone had been ripped from the wall. Some bloody fingerprints, not hers, were discovered but were never identified. A phone book was open to the page of emergency numbers. Investigators later said the blood probably came from a superficial wound—there was not enough of it to have been fatal.

There were various reports of a dazed woman walking along a highway and of a mysterious gray car, but nothing ever came of them.

There was also speculation that Mrs. Risch staged her own disappearance because she was unhappy with her life. A reporter had discovered that Mrs. Risch had checked out from the local library more than twenty books on murder and disappearances. However,

friends maintained that she was devoted to her family and could not believe she would abandon them.

Adding to the tragic strangeness of the case was the fact that both of Joan Risch's parents were killed in a fire when she was nine years old, and she had been raised by an aunt and uncle.

THE MYSTERIOUS FOUNDATIONS

Many Ridgefielders have wondered about the two carefully made stone foundations—one with a chimney—that have for decades stood topless alongside Old Branchville Road, opposite Nod Road. Were there ever buildings atop them, and if so, where did they go?

Conversations with many old-timers, as well as people in the neighborhood, have come up with no certain answer. One story, related to A.J. Di Mattia, who lives near the foundations, was that the property had been owned by some Germans or Swedes who abandoned it at the outbreak of the First World War.

The foundation was built by Joseph John Knoche early in the twentieth century, according to his grandson, Joe Knoche. The elder Knoche was a stonemason so respected that impressionist artist J. Alden Weir hired him to build many of the still-standing stone walls at his farm—now Weir Farm National Historic Site nearby. According to Joe Knoche, the owner of the property—he did not know who it was—never opted to complete the job, and the foundations have always been topless.

A 1935 map of Ridgefield shows the place being owned by someone named Jacobesen, but the mapmakers were notoriously sloppy about surnames, and it could have been "Jacobsen." However, a 1912 map shows at least one structure existing there, belonging to Herbert Spencer Greims and his wife, Mary Hearn Greims, as part of their estate.

The Greimses came to Ridgefield in 1907 and created the sizable estate along Old Branchville Road. They built a number of buildings, including the barn-turned-home that Mr. Di Mattia lives in, most using the same kind of stone construction techniques found in the abandoned foundations. These, too, were probably the work of Mr. Knoche.

Mrs. Greims, who signed her work M. Hearn Greims, was a regionally known artist who had studied at Cooper Union and under noted artist George Smillie, who lived on Main Street. Her work was widely

This chimney with fireplace is a prominent feature of the mysterious foundations in the woods off Old Branchville Road. *From the author's collection.*

exhibited, including at the National Academy of Design in New York and at the Metropolitan Museum of Art. Her father, George A. Hearn, was a prominent art collector who gave money and paintings to the Met. The Hearn family owned the large New York City department store called Hearn's, and Mr. Greims became a president of the company. He and Mary were married in 1902. She died young in 1927 and he in 1946 at age seventy-one.

The Greimses may have intended the buildings as a studio and exhibition place for Mrs. Greims; she and other Ridgefield-area artists would stage exhibits of their work in the early twentieth century at various locations in town. Or the buildings could have been planned as a sort of "hunting lodge" for estate guests—that was still wild country back in the 1910s. Or they could simply have been a caretaker's cottage and garage. Still, it is unknown why they were never completed.

Today, the foundations are actually the property of the Town of Ridgefield, which has done nothing to maintain them. When the neighborhood was subdivided in the 1970s, the foundations and 2.9

acres with them were donated to the Conservation Commission. It's considered "open space." And as foundations go, they are about as open as it gets.

THE LOST MINE

A road off New Road in Farmingville is called "Lost Mine Place." Why is the mine lost and what did it produce when it wasn't lost?

Lost Mine Place, serving the Hunting Ridge subdivision, is on part of an old Lee family farm that dated back to the 1700s. For a long time, the land belonged to Robert A. Lee, who died in 1982. Five years later, the family sold twenty-seven acres to developers who obtained approval for the eleven-lot subdivision.

The developers wanted to call the road Hunting Ridge Place, but town officials rejected the name as being too similar to Hunter Lane, also in Farmingville. As the town's adviser on road names (jokingly called the "Official Adviser on Municipal Thoroughfare Nomenclature"), I suggested Lost Mine Place.

Years ago, the late Stanley Walker of New Road had heard reports that an old silver mine had existed in what are now woods off the north side of New Road. While he spent many hours searching for the mine, he was never able to locate it. Mr. Walker told me he suspected that the opening to the mine had been covered up, either to hide it or to prevent people from falling into it.

Robert Lee, who was born on the Lee farm before the turn of the twentieth century, had also heard the mine reports but did not know its location.

Silver was not unknown in our area; witness the well-known section of Norwalk and New Canaan, called Silvermine. (Ridgefield's Silver Spring area was supposedly named not for the metal but for the silvery clarity of the spring water.)

Wilton had a silver mine off Route 7, somewhere near Georgetown, with a history of greed. According to Hamilton Hurd's *History of Fairfield County*, the mine was first worked around 1765. "It was originally divided into shares and worked for a short time before the Revolutionary War… The manager or overseer, after having sent away all the ore that had been dug, under pretense of having it examined, suddenly left 'between two

days,' leaving the shareholders minus the amount of their subscriptions, and also their share of 'the rocks,'" Hurd said. "Many persons in comfortable circumstances, who had subscribed liberally towards working the mine, were by this operation considerably reduced in circumstances."

Sometime after the Revolution, "some Englishmen" worked the mine in partnership with the owner, Captain Azar Belden. They dug about 150 feet down. "They built a small shanty in the woods near where they lived, and where, during the night-time, they coined a considerable amount of bullion," Hurd reported. "They kept their silver hid from the vigilance of officers and sightseers. After having worked the mine some time, they suddenly absconded, taking their treasure and about five barrels of ore with them."

Perhaps they figured it was their compensation for losing the Revolution.

An Island Without Water?

People today are often perplexed by the old name Island Hill, recalled in Island Hill Avenue. Even folks who lived in this neighborhood early in the twentieth century could not explain the origin of the term. One suggested that the name stemmed from the tendency during heavy snowstorms for the area around Grove Street and Danbury Road to become a "sea of snow," with the hill to the west an "island" in the snow. While that wasn't the origin, the answer may seem nearly as far-fetched: Island Hill overlooked "the Island."

"The Island" was a shortened form for "Grassy Island," the area along Danbury Road roughly from Copps Hill Common north to the southern entrance to the Fox Hill condominiums. The area was called an island because it was almost surrounded by swampland in the eighteenth and early nineteenth centuries. (Much of the swamp has since been filled in, particularly on the south and west sides of the Island.)

The name Grassy Island fell out of use in the 1780s. Around the same time, "ye Island" or "the Island" began to appear more frequently in the land records. However, as early as 1709, the proprietors had described a division of meadowland north of the village as "lay'd out on ye south side of ye Island."

Although "the Island" was in use at the town's founding, the term "Island Hill" does not appear until 1820, when members of the Dauchy

family transferred title to three acres "on the top of the Island Hill." Thanks to Conrad Rockelein, the German-born village barber who subdivided Mountain View Park in 1910, this unusual old name is retained today in Island Hill Avenue, so called at least by 1927.

WHO WAS OLD SIB?

Old Sib Road runs from North Salem Road up the side of West Mountain and on to New York State, one of the longer town roads. Yet no one seems to know for sure who—or what—"Sib" was.

Neither the name nor the highway is very old. The road does not show up on maps until the twentieth century, although it may have been an old logging trail in the nineteenth and maybe eighteenth centuries. The name, or a name like it, does not appear in any deed before 1900.

Sib is sometimes a nickname for Sybil, but we could find no one by that name connected with that area.

Sib as a common noun long ago fell out of use. One meaning, employed into the nineteenth century, was "kinship" or "relationship."

Frank Baxter, whose family had lived in the neighborhood for more than a century, told me in the 1970s that he did not know the origin. As a child, he called it "Port Road" because it led to the Port of Missing Men Resort at the state line. Julius Tulipani, a former selectman who in his youth helped build the roads around the Port of Missing Men in the early 1900s, knew the road only as Tea House Road; the Tea House was the Prohibition-era name for the Port resort, which had served libations stronger than tea—and maybe still did.

John Mullen said in a 1975 interview that the name might have been a corruption of "Sid," nickname of Sidney D. Farrar. Mr. Farrar, a professional baseball player in the 1880s and father of opera star Geraldine Farrar (see page 29), had a thirty-acre farm on North Salem Road from 1923 until his death in 1935; Farrar Lane was named for him. While his land did not border Old Sib Road, it was close to the beginning of the highway at Tackora Trail.

Adding some weight to Mr. Mullen's suggestion are two 1951 maps for portions of the subdivision called Eight Lakes, through part of which Old Sib Road runs. The two maps label the highway "Old *Sid* Road" while a third in the same series says "Old *Sib* Road."

A view of Old Sib Road, with Turtle Pond at the right, from around 1920, when the road led to the Port of Missing Men, also called the Tea House. *Postcard from the author's collection.*

However, Old *Sib* had made its debut on a map five years earlier, in 1946, when the town's first zoning map was published.

Old Sib Road was built by laborers, including Mr. Tulipani, hired by H.B. Anderson; it was part of a network of roads designed for the recreation of users of his resort. Many workers came here after having built a huge dam at Valhalla, New York, and quite a few settled here.

While narrow, Old Sib is among the best-built roads in town. James Loughlin, who moved to the road in 1952 and had done a little research into it, said it's a Telford road, a design, named for its inventor, that employs a stone foundation. Large, long stones were stood on edge to make the base. Next, small rocks were used to fill in the gaps between the large stones. It was almost as if someone built a stone wall on its side. Finally, gravel and dirt was laid atop the stone base.

"That road should be there forever," said Mr. Loughlin. "God help the contractor that has to come in and put pipe in under that road."

THE PLACE THAT SOUNDS FAKE

Bogus is a peculiar term but also a word whose appearance in Ridgefield predates its first officially recognized use in the English language.

The *Oxford English Dictionary* reports that bogus is an American word that first appeared in print in 1827, when an Ohio newspaper used it as a noun for an apparatus for coining counterfeit money. "It was a mysterious-looking object, and someone in the crowd styled it as a 'bogus,' a designation adopted in the succeeding numbers of the paper," the editor later reported.

The scholarly *OED* adds, "Many guesses have been made and 'bogus' derivations circumstantially given." For instance, it might have been short for "tantrabogus," a word once applied in Vermont to any ill-looking object, and may be related to "bogy," which meant an evil one, like a boogeyman. Although bogus started out to mean a counterfeiting device, it became more commonly used to describe what was counterfeited— such as a "bogus bill."

Wikipedia says the term *bogus*, used to describe counterfeit coins, can be traced back as early as 1797.

However, Bogus turns up in Ridgefield's land records forty-five years before the incident in Ohio and fifteen years before the earliest citation. The first reference is in a 1782 deed for "land at Bogus so called." The term *Bogus Road* was in use by 1806, making it one of the oldest road names in town. The southern portion of its length today is a dirt path through the Hemlock Hills Refuge in Ridgebury; the northern part is in the 1950s Hemlock Hills subdivision. The road was one of the routes used by the British troops heading back to Long Island Sound after burning Danbury and before the Battle of Ridgefield in 1777.

Where did our word come from, and what did it mean to the Ridgefielders who used it? Inspection of eighteenth-century land and tax records in Ridgefield and Danbury uncovered no family named Bogus, or even Boges, which seems to eliminate that possibility as a source. But it's interesting to note that the United States Geological Survey maps record a "Bogus Mountain" in Bethel and another in New Fairfield, plus there's a "Bogus Brook" in Redding, suggesting the word had been in common use hereabouts.

George R. Stewart, author of books on American place names, cites Bogus Creek, California, and Bogus Hollow, Iowa, as places where counterfeiters operated. However, he also observes that Bogus is "a

name applied to features, especially in the California mining districts, to indicate some deception or humbug."

Research done by Ridgebury historian Edwin D. Liljegren indicates "Bogus" was the area we now call Ned's Mountain. Anyone who has trekked through the Hemlock Hills Refuge on Ned's Mountain knows that it includes rocky, steep, rough terrain and would be extremely difficult to use as farmland. One of Ridgebury's early settlers may have been granted land in this area, only to find out later how awful—or bogus—it was and applied the slang term. It would have, in effect, been "counterfeit" or "worthless" land, suitable perhaps only for woodlots—and even then, woodlots of questionable quality since most of the trees may have been evergreens, a poor fireplace fuel.

WHERE HAVE ALL THE OLD CHURCHES GONE?

Ridgefield is a three-hundred-year-old town, with many eighteenth-century houses. Yet it doesn't have any eighteenth-century churches. Why?

Houses of worship were different from houses of residence: they often weren't built as well, and they were simply replaced when they were outgrown or worn out.

Ridgefield's oldest church is Ridgebury Congregational, built in 1851 (it replaced the first church, built in 1768). In the world of churches, that's pretty old. Consider that in all of Connecticut, the oldest extant church building is the Abington Congregational Church in Pomfret, built in 1751—more than a century after the state was settled in 1635.

Through the 1700s, Ridgefield had two Congregational congregations and two Episcopal congregations—one each in Ridgefield village and in Ridgebury. By 1800, the First Congregational Church already had at least two buildings, and Saint Stephen's had two—the first one was burned by the British in 1777 because it held rebel stores.

Most of the old churches succumbed to age—and not necessarily old age. Some lasted only forty or fifty years.

They were probably not built as well as houses for a couple of reasons: they were used for only a small part of the week, and the builders did not have a lot of money or resources to contribute to their construction. The original First Congregational Church—the meetinghouse was also used for occasional town functions—was built in the early 1730s, and by 1765,

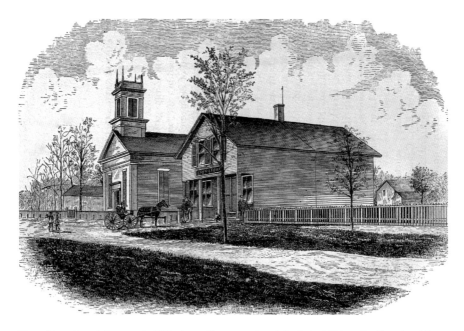

The oldest church in town is Ridgebury Congregational, built in 1851 and still active. Next to it in this 1878 engraving is a store that included a post office. *From Daniel Teller's* The History of Ridgefield.

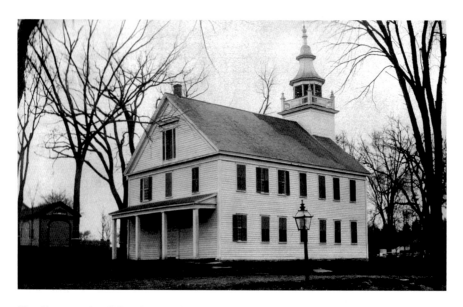

The Congregational church, completed in 1800, stood on the "green" by today's War Memorial. It was removed around 1888 when a new church was built. *From the* Ridgefield Press *archives.*

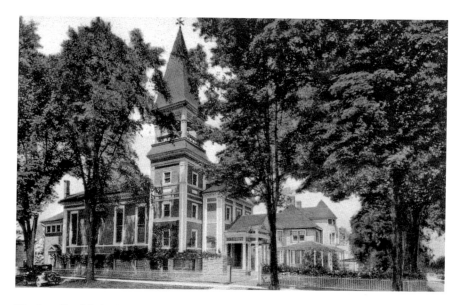

The Jesse Lee Methodist Church stood at the corner of Main and Catoonah Streets from 1841 until 1964. The church is gone, but the rectory is still there. *Postcard from the author's collection.*

townspeople were already talking about replacing it (which, in good old New England fashion, didn't get done until 1800).

Money was hard to come by. Saint Stephen's Church, completed in 1791, was seriously deteriorating by 1817 because of lack of money to keep it in repair, and the church vestry voted to name a committee to repair the roof and windows and to build a steeple that had been cut from the original construction plans. Church members were asked to pledge money. Two years later, the work was done, but the congregation couldn't afford a bell for the new steeple until 1828.

Of course, congregations outgrew buildings, too. By January 1841, Saint Stephen's vestry had decided its building was too small, and in uncharacteristically speedy fashion, a cornerstone was laid by August for a new building, and the first service in it took place on September 5, 1842.

One of the most beautiful churches was lost in 1964 after the Jesse Lee Methodist congregation decided to move south on Main Street and sell its landmark building at the corner of Main and Catoonah Streets. Built in 1841 and subsequently enlarged, the building could no longer hold the growing congregation, and there was no room for expansion. The

church was razed and replaced with a commercial building. However, the parsonage next door still stands, holding offices and shops.

Only one outgrown nineteenth-century church has survived, but not for worship. Today's Thrift Shop on Catoonah Street was an early Saint Mary Church—it could barely hold a catechism class today.

Congregations are still outgrowing buildings. Saint Andrew's Lutheran Church, built in 1969, was replaced by a larger, new church in 2013. Plans are to eventually raze the old one.

CLAMS IN THE GARDEN

People puttering around in their yards, especially when digging in gardens, sometimes find old buried clamshells. Some wonder if they are fossils. Actually, they are probably just old garbage.

In the eighteenth, nineteenth and early twentieth centuries, Ridgefield did not have an official town dump, much less a transfer station. This was farm country; most people had a lot of land, and they'd dump their solid garbage in an unused corner of their property.

However, for much of the town's history, people did not produce a lot of garbage, so disposal did not require much space. Most animal and vegetable products were almost completely used—flesh eaten, fat converted to soap, bones ground for fertilizer, hides tanned for leather products, vegetable trimmings used for compost. Other wastes were burned. Containers, like bottles and jars, were reused—unless they broke, in which case they wound up on the trash heap, which archaeologists today may label a "midden."

While shells were sometimes ground up as a soil conditioner—they are basically lime—usually it wasn't worth the trouble for small amounts. Consequently, after the contents were eaten, the shells were often tossed on the "heap" out back or into a hole that was later covered over.

And yes, folks back then ate fresh clams and oysters, perhaps fairly frequently. In his diary entry for March 21, 1865, Jared Nash, who lived on Silver Spring Road, wrote: "Clear and verry warm for the time of year. Father went to Norwalk to carry potatoes, and went a claming." Other diary entries suggest the Nashes frequently journeyed to the Sound—less than fifteen miles away—to go "a claming" in the creeks and on the bars along the shore. Clams were free, plentiful and

good eating—well worth the trip. There were dealers, too, who brought the shellfish to local inland markets.

However, shells found under the backyard might be from even earlier. Our native American Indians also visited the shore for shellfish, bringing it back to eat at their Ridgefield villages. They, too, had their waste places. However, if you find shards of plates or pots and broken glass (or even whole old bottles) in the same area as the shells, chances are you've uncovered an old farm's garbage dump, not an Indian village's.

THE FURRY—OR NAKED—MOUNTAIN

In Ridgebury, there's a Bear Mountain, but it may be a naked one, really.

Back in the 1730s, when Bear Mountain got its name, there were bears in Ridgefield—and there still are. But Bear Mountain, a ridge reaching an elevation of 794 feet south of George Washington Highway, may have gotten its name from a different source.

The name is first mentioned in 1739, when the boundary line between Danbury and Ridgefield was perambulated—a colony-required practice of periodically walking the town lines to check and restore boundary markers. When perambulators reached Ridgebury, they passed "a stake sett in ye ground on stones laid to it, which is on ye west side of a hill near against the northeast end of ye Bear Mountain."

Bears may well have been sighted there; they may also have lived in the hill's rocky, craggy inclines. Writing in 1800, the Reverend Samuel Goodrich said bears had lived in Ridgefield but were "extinct."

Bears have returned in modern times, particularly as more trees have grown back with the end of farming. Since the 1990s, sightings have become fairly regular, usually in the spring. Probably all are just passing through; none probably overwinter here, but they may have dens at Ward Pound Ridge Reservation in nearby New York State and perhaps in woodsy Redding.

However, the hill in Ridgebury has also been called Bare Mountain, leading to speculation that the name is not ursine in origin. A 1752 deed described eight acres "situate in Ridgefield North Pattent, lying westerly from ye Bare Mountain." A reference is also made to Bare Mountain Brook.

While "bare" may simply be a misspelling, George R. Stewart, in *Names on the Land*, says, "Most...mountains had thick forest all the way

to the top. But some were higher or more wind-swept, or more rocky, or had perhaps been cleared by fire. These grassy-topped or rocky-topped mountains stood out sharply among the others and were good landmarks. In all the colonies they were most often named Bald Mountain, sometimes Bare Mountain, occasionally Naked Mountain."

Stewart added, "Later, after the forests had been cleared, these mountains were not so individual, or sometimes the trees grew on a burned summit. Then, because the sounds were the same, men often wrote Bear Mountain. So there is no way of telling which it first was, but there are so many more of these than of mountains named for other animals that most of them were probably Bare Mountain."

The late Otto H. Lippolt developed Bear Mountain Road as part of his 1959 Hemlock Hills subdivision. On a 1957 map, Mr. Lippolt called the planned road "Bare" Mountain Road, suggesting he may have believed in the "bald top theory." However, someone (either he or a town official) opted for the furry version, which is, after all, more colorful.

DOUBLE DEATHS

On Saturday, August 25, 1888, Dr. Archibald Y. Paddock and his eighteen-year-old son, Harry, had a late breakfast and decided to go target shooting near their large home on Main Street, just south of Saint Stephen's Church. "Rifle shooting was a favorite diversion of both father and son," the *New York Times* later reported. "They took their rifles and went to the field at the rear of the house where the butts were erected for target practice. They were never again seen alive."

A coroner subsequently ruled that Harry was doing something with a target when his father accidentally shot and killed him, but no one knows for certain just what happened that led to the boy's death.

"The father was overwhelmed with grief, and in an instant went to the son, whom he loved as life itself, knelt down, and with the same weapon that enacted the first scene in the tragedy, ended his own life," the *Boston Evening Transcript* said. The father's body was found lying atop the son's, the *Times* noted.

Dr. Paddock, a retired New York City dentist, had been a pillar of the community: treasurer of the First Congregational Church, master of Jerusalem Lodge of Masons and a close friend of Governor Phineas

The Paddock family plots in Ridgefield Cemetery: Dr. Paddock is on the right, and the son he killed is at the far left. *From the author's collection.*

Lounsbury, who lived across the street in what's now the Community Center. By all accounts, he deeply loved his son, who had been an excellent student and athlete and who was set to begin a career in New York City in the fall.

The coroner ruled Harry's death was an accident and that Dr. Paddock's death was caused by "temporary insanity." Harry and Archibald were buried in the family plot in Ridgefield Cemetery. For whatever reason, their gravestones are about as far apart as the plot allows.

Dr. Paddock was also involved in notable deaths of a different sort. In 1874, he was having some sand excavated on North Salem Road when two skeletons, believed to be Hessian soldiers who fought with the British at the Battle of Ridgefield, were uncovered. "The skeletons were lying near each other, side by side," Ridgefield historian George L. Rockwell said. Dr. Paddock "took possession of the skeletons. One was almost perfect, and Dr. Paddock exhibited it at the Centennial Exposition in Philadelphia in 1876." He refused a $200 offer for it.

Samuel S. Denton, a local merchant, later acquired the Paddock house and decided to move it to the north end of Main Street. At the curve by Casagmo, the building would not fit between the Casagmo stone wall and the hill by the house opposite. Denton asked Casagmo owner George M. Olcott for permission to temporarily take down part of the wall. Olcott refused, so after leaving it in the middle of the road for a couple days, Denton sawed the house in two so it could fit. In the process, the nearly perfect skeleton was found in a sealed closet.

Half of the Paddock house still stands on Main Street just north of Casagmo—the other half, which had been located nearby, was razed years ago. The whereabouts of the skeleton are unknown.

PART VI
THE LAND OF OLD

How our geography and natural history were seen and used over three centuries.

WHEN WE WERE BIGGER

Ridgefield was once much larger than it is today, extending well into New York State to the west and all the way to New Fairfield on the north side.

Before 1730, Ridgefield covered much of today's Lewisboro, New York, including the hamlets of South Salem and Vista. If you look at a map of Lewisboro, the slender mile-and-three-quarters-wide leg that runs south to the New Canaan line, east of Pound Ridge, was all once Ridgefield. So was what is now eastern North Salem, including part of Peach Lake.

In 1731, the western edge of the whole colony of Connecticut was ceded to New York in a land swap that gained Connecticut the town of Greenwich. The traded land, called the Oblong, settled a longstanding dispute over the location of the Connecticut–New York line.

Ridgefield wasn't so hot on the deal and wanted compensation for its loss, which included rolling hills used for wheat and other crops and the lofty western slopes of West Mountain, a source of timber. So the general assembly granted the town a large wedge of territory north of

A 1799 map showing Ridgefield's boundaries extending north to New Fairfield (where "Bull P[ond]," now called Ball Pond, is). Dashed line at left shows extent of old "Oblong." *"A new map of Connecticut from the best authorities" by A. Anderson, MAGIC Historical Map Collection, University of Connecticut.*

and including part of today's Ridgebury. This grant encompassed the western section of modern-day Danbury to New Fairfield.

To gain clear title, the town also had to purchase the granted land from its American Indian owners. That occurred on December 19, 1739, when Betty, Jacob Turkey and Mokquaroose sold the town what was later called the "Betty Grant." The price? Six pounds, five shillings—very roughly, about $600 modern dollars.

It was a big tract at what was undoubtedly a bargain price, but there was a serious problem: most of it was too far from the center of Ridgefield. The people who lived there had a long, slow ride over poor,

hilly roads to reach Ridgefield Village, where all voting and other civil functions took place. So as early as 1787, Ridgeburians were petitioning to secede from Ridgefield and form their own town. Ridgefield didn't want to lose this valuable expanse, so it fought the petitions locally and in Hartford. Various votes on the issue continued in 1792, 1816 and 1822, none successful for the Ridgeburians.

But as Ridgebury kept growing in population and as the trip to Ridgefield continued to be so difficult, officials of Ridgefield, Danbury and Connecticut finally agreed in 1846 for Ridgefield to cede a big chunk of Ridgebury to Danbury, whose government center was much closer. Ridgefield lost most of Mill Plain (where Trader Joe's is), plus today's Richter Park golf course and the western parts of King Street and Middle River districts.

Ridgefield apparently got nothing in exchange—except for fewer headaches. Tax collecting in the upper reaches of Ridgebury—as far as twelve miles away—must have been difficult, especially with all those ornery Ridgeburians to deal with.

THE STREAK IN THE SKY

Around daybreak on December 14, 1807, fourteen-year-old Samuel G. Goodrich got out of bed to build a fire at his home on High Ridge. "Suddenly the room was filled with light, and looking up, I saw through the windows a ball of fire, nearly the size of the moon, passing across the heavens from northwest to southeast," the author known as Peter Parley later recounted in his autobiography, *Recollections of a Lifetime*. "It was at an immense height, and of intense brilliancy."

Goodrich continued, "Having passed the zenith, it swiftly descended toward the earth: While still at a great elevation it burst, with three successive explosions, into fiery fragments. The report was like three claps of rattling thunder in quick succession. My father, who saw the light and heard the sounds, declared it to be a meteor of extraordinary magnitude. It was noticed all over the town, and caused great excitement."

The next day, the Goodriches learned that "huge fragments of stone had fallen in the adjacent town of Weston…The story spread far and wide, and some of the professors of Yale College came to the place, and examined the fragments of this strange visitor from the skies."

The Goodrich family home, from which young Samuel saw the 1807 meteor, still stands on High Ridge opposite Parley Lane. *From* The History of Ridgefield *by Daniel Teller.*

Actually, most pieces fell in what is now Easton but was then part of Weston. Yale, which owns many fragments and which exhibits the largest at the Peabody Museum, says several large stones, including one of about two hundred pounds, had been smashed on the rocky ground. Others were broken up by the finders: "Strongly impressed with the idea that these stones contained gold and silver, they subjected them to all the tortures of ancient alchemy, and the goldsmith's crucible, the forge,

and the blacksmith's anvil, were employed in vain to elicit riches which existed only in the imagination," a Yale professor wrote.

Two Yale professors got "a considerable number of specimens," including the largest, which weighed 36.5 pounds and was unbroken. However, of about 350 pounds of the meteorite that fell, fewer than 50 pounds worth can now be accounted for. "Much of the rest undoubtedly gathered dust on numerous nineteenth-century mantelpieces in western Connecticut before being thrown away," Yale says.

SNOWS OF OLD

While each winter seems to bring its "big storm," Ridgefield has gotten some really major snowstorms over the years.

The earliest recorded big snow was January 12–14, 1853, when about two feet fell. Diarist Anna Marie Resseguie of the Keeler Tavern reported on the fourteenth, "Snow banks over the tops of the fences, but few out to-day as the roads are almost impassable this morning."

After a blizzard on March 21–22, 1861, thirty men with two span of horses and three yoke of oxen were needed to clear a ten-foot-high snowbank on Branchville Road near Nod Road so sleighs could reach Branchville station, diarist Resseguie said. On January 18, 1867, drifts up to eleven feet high shut down Ridgefield for two days.

The most famous nineteenth-century storm was the Blizzard of '88, when at least two feet fell, and winds created banks as high as twenty feet across some roads. The *Ridgefield Press*'s "Blizzard Edition" carried this stacked headline over the storm story:

> *A Howling Blizzard!*
> *The Storm Rages Furiously for Two Days!*
> *Cities and Towns Paralyzed!*
> *Ridgefield Shut Off from Outer World for Nearly a Week!*
> *Traffic on All Roads at a Standstill!*
> *Ridgefield Fortunate! She Escapes the Terrible Human Sufferings Experienced Elsewhere.*
> *Cheering News from New York and Other Points.*

That storm continued to be a benchmark for snowfalls for decades to come.

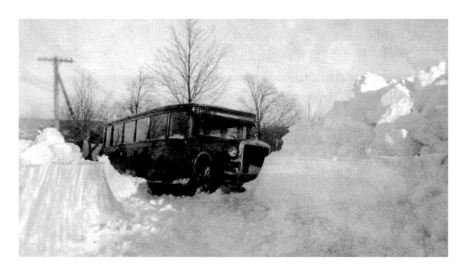

The bus from Branchville Station to the village was stuck at the top of Branchville Road for two days after the blizzard of 1926. *From the* Ridgefield Press *archives.*

For instance, on February 4, 1926, a blizzard dumped three feet of snow on the town, prompting a *Press* headline, "Raging Wind and Heavy Snow Reminded of Big Blizzard of '88." The town was snowbound for nearly two days. Cars and even the train were at a standstill. And the bus from Branchville Station to the village got stuck at the top of Branchville Road, forcing passengers to hike the rest of the way. It wasn't until Saturday that the bus was freed.

Only eight years later, a February 22, 1934 storm was called the "Worst Blizzard Since 1888" in a banner *Press* headline after more than two feet fell. Drifts as high as eight feet were reported, and roads were impassable for miles.

Other big storms included one on March 19, 1956, when twenty-two inches fell on the eve of spring, and on February 11, 1983, when, in only twelve hours, nearly two feet came down, one of the fastest accumulations on record. Connecticut governor Ella Grasso shut down all roads in the state.

One of the most unusual storms occurred on October 4, 1987, barely two weeks after summer ended. Only three inches fell, but all trees still had their leaves and, unable to handle the weight of the wet snow, many dropped limbs. Most of the town lost power—some areas for four days.

During the winter of 1995–96, the most snow of any winter in the twentieth century fell on Ridgefield—approximately 111 inches. That included January 7–8, 1996, when the town got 21 inches in twenty-four hours.

Snow can lead to other problems. Back on April 15 and 17, 1854, more than eighteen inches fell—unusual for mid-April. Ten days later, temperatures in Ridgefield reached seventy degrees, and a few days after that, rains and the melting snow led to what the *Hartford Courant* called the worst flood in two hundred years. Only two bridges were left on the train line between Branchville and Norwalk, and several local mills were swept away.

Of Sticks and Sleepers

Railroads, by the way, were providing farmers with a new "crop" in the 1800s.

By late fall, Ridgefield's farmers in the eighteenth and nineteenth centuries were finishing with their food crops and turning to tasks they didn't have time for during the growing season. These included repairing buildings and equipment, gathering and cutting firewood and fixing fences. Many also had "side jobs" to earn extra money. Some, for instance, worked as cobblers in the winter, making shoes for big and small companies (as well as their own families). And some Ridgefield farmers made railroad ties.

The great expansion of the American railroads in the mid- to late nineteenth century required a huge number of ties. Some three thousand are used for each mile of track. Millions were needed, not only for new lines being laid but also to replace ties that rotted. (Depending on environment, ties might survive only a few years; today, treated with creosote, they can last thirty to forty years.)

In 1850, there were 9,000 miles of track, mostly east of the Mississippi. More than 160,000 miles were in use forty years later, requiring nearly a half billion ties. In 1890, railroad ties were the largest single use of wood in America. Farmers who owned some woodland could earn extra income by cutting trees, especially chestnut and oak, and turning them into ties.

Until the 1940s, most railroad ties were hand-hewn by men working in pairs. Straight hardwood trees that were not too wide—around a foot across—were felled and cut into eight-foot, six-inch lengths. According

to the diary of Jared Nash, a Ridgefield farmer in the 1860s, these were often locally called "sticks." In other places, then and now, they have been called "sleepers."

To work on a tie, the wood was placed at right angles on a pair of logs to raise it off the ground. Bark was peeled off with a barking spud, a tool that looked something like a shovel. The workers snapped or marked a line down the log to delineate where each side would be; this was called the "cut line." Then, using a felling axe, a worker would chop into the side of the log about once every six or eight inches; the cut would be only as deep as the line that had been scored for the side—a process called "cutting to the score."

Once the side had been scored, the worker could use a broadaxe to move down the side of the log, chipping away the scored pieces. This was called "hewing to the line." The result was a rectangular tie.

More than 90 percent of ties in America are still wood; the rest are concrete, steel or composite plastic—substances much more commonly used in Europe. But today, farmers pretty much stick to food crops and leave the sticks to the loggers.

ROCKEFELLER TREES FROM RIDGEFIELD

While trees brought farmers some cash, they've also brought the town some fame. And they've brought smiles to millions of faces in New York City. That's because Ridgefield has supplied at least three Rockefeller Center Christmas trees, including the very first *official* tree.

The first tree at "30 Rock" was unofficial, erected in 1931 by construction workers before the center was completed. The twenty-foot balsam fir was decorated with "strings of cranberries, garlands of paper, and even a few tin cans," according to historian Daniel Okrent.

The first official tree was installed in 1933, just after the center was completed. According to a story in a 1933 *Press*, the Norway spruce came from Outpost Nurseries in Ridgefield. Outpost, operated by Colonel Louis D. Conley, covered many hundreds of acres in the Farmingville and Limestone districts of town and included what is now Bennett's Pond State Park. Most of the nursery was later subdivided by various developers, and many roads in that part of town take their names from trees and shrubs that Outpost grew on neighborhood land, including

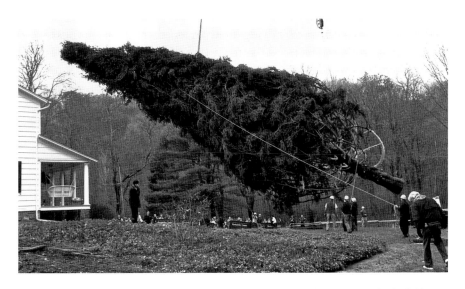

A crane lifts the Kinnairds' spruce to an awaiting truck in 2006, at least the third Ridgefield tree to wind up in Rockefeller Center for Christmas. *Photograph © Sally Andersen-Bruce.*

Copper Beech Lane, Linden Road, Birch Lane, Cherry Lane, Dogwood Drive, Laurel Lane and, of course, Nursery Road.

Outpost was one of the largest retail nursery businesses in the East. Among its many jobs between 1925 and World War II were plantings for the 1933 Chicago World's Fair; the 1939 New York City World's Fair; the National Art Gallery in Washington; parks along Riverside Drive and elsewhere in New York City; Harvard, Yale and Williams Colleges; Narragansett and Monmouth Raceways; and the estates of such people as Cole Porter, Lowell Thomas, Governor Thomas E. Dewey, President Franklin D. Roosevelt (at Hyde Park—see page 25), columnist Walter Winchell, actor Robert Montgomery and the Buckleys at Sharon.

The fifty-foot Outpost tree was decorated with seven hundred blue and white bulbs. Today's trees carry some thirty thousand lights and are up to one hundred feet tall.

The next Ridgefield tree I could find was in 1994. The eighty-five-foot Norway spruce belonged to Maria and Alan Egler, who feared it would one day fall on their house. However, "when my wife saw that tree going out the driveway in that one-hundred-foot flatbed, she sobbed," Mr. Egler told a reporter.

In 2006, an eighty-six-foot Norway spruce was felled on the property of Robert and Deborah Kinnaird. With a forty-eight-inch trunk, it was the heaviest tree the Rockefeller fellers had ever handled.

Mr. Kinnaird, a longtime Ridgefielder, took a bit of teasing for allowing his century-old tree to be dispatched. Fellow longtime Ridgefielder and friend David Gelfman claimed in a letter to the *Ridgefield Press* that Mr. Kinnaird was being considered by the "National Society of Deforestation and Destruction" for its annual award for "Ultimate Desecration of Nature."

At three, Ridgefield may hold the record for the largest number of Rockefeller Center Christmas trees supplied by any one town. However, I've been unable to find a complete list of all the contributed trees, so I can't tell whether another community equals or surpasses ours, or whether Ridgefield may have supplied more than three.

CASHING IN ON COWSLIPS

In April, a wildflower drew the eye of savvy farmers, offering them a free treat that could warm their stomachs, brighten their rooms and even line their pockets. We call them marsh marigolds, but old Ridgefielders knew them as cowslips.

Diarist Jared Nash reported on April 11, 1865, "Emily and I went and got some cowslips." Emily was his wife, and the Nashes lived on lower Silver Spring Road in an area filled with wetlands of the Silver Spring Swamp, the kind of environment cowslips love. These large yellow buttercups live in and at the edges of water, offering the first big blooms of the season and a chance to decorate winter-weary homes.

Cowslips were also popular as a spinach-like dish. William Hamilton Gibson wrote in 1880: "The eager farmer's wife fills her basket with the succulent leaves she has been waiting for so long; for they'll tell you in New England that 'they ain't noth'n' like cowslips for a mess o' greens.'" Being bitter like most buttercups, they had to be well boiled first. That bitterness, incidentally, is protection from today's voracious deer and other grazing predators.

There was gold in those yellow flowers, too. Enterprising farmers picked bunches of cowslips to send to nearby cities, where boys would sell them on street corners to people eager for fresh spring blossoms.

The plant's name sounds romantically agrarian but isn't quite. Cowslip, named for a European barnyard weed, is from the Old English meaning "cow slop"—that is to say, cow crap.

BIG BUG OUTBREAKS

The 2013 appearance of the seventeen-year periodical cicadas, *Magicicada septendecim*, made big news in the Northeast. Many areas had huge numbers of the insects emerge, filling the trees with bugs and buzzing, but in Ridgefield, there was not much of a show. However, the town has not lacked for spectacular insect eruptions over the years. Unlike with cicadas, which are harmless to humans and the environment, past insect outbreaks here have been plagues.

In 1970, for instance, the town experienced two huge invasions of caterpillars. Millions of elm spanworms ate big chunks out of the spring leaves. Later, when the small white moths emerged, it looked as if it were snowing in August.

Far worse was the gypsy moth caterpillar, first noticed here around 1908. There was a major outbreak in 1970, almost simultaneous with the elm spanworm, prompting many homeowners to fear their trees would die from the defoliation. In 1971, gypsy moth caterpillars returned in even greater numbers. As they ate, their droppings were so plentiful they sounded like rain as they fell through the yet-to-be-eaten leaves. By June, Ridgefield's deciduous woods looked as if it were December, and more than six hundred people at a town meeting voted to hire helicopters to spray the whole town with pesticides. However, the copter company backed down after conservationists—led by beekeeper and organic farmer Dan McKeon—threatened a lawsuit.

The gypsy moths returned in 1980–81—populations tended to explode every eight to ten years. However, when they returned again in 1989, nature took control. A previously unknown fungus and a virus combined to kill most of the caterpillars, and countless shriveled bodies could be found in trees and on the ground. "We've never seen anything like this," said the state's entomologist. It was the last year gypsy moth caterpillars defoliated Ridgefield.

Tent caterpillars, which tend to attack fruit trees, were a great problem in Ridgefield when it was an agricultural community. An outbreak in

the 1920s was so bad that it threatened local fruit crops. In May 1926, the Ridgefield Garden Club sponsored a contest for schoolchildren to collect tent caterpillar egg clusters. Fourth-grader Gino Polverari won ten dollars for coming in first with 10,349 egg cases, followed by Nancy Jones with 9,204, which earned her eight dollars.

Insects had created problems centuries ago, too. For several years starting in 1780, reported the Reverend S.G. Goodrich, "the canker worm destroyed our apples and apple trees…to an allarming degree." However, in 1794, "there came in to the orchards several flocks of uncommon birds a little larger than a bluebird of a brownish colour and picked the worms from the trees." Flocks of pigeons helped, and "the frost which happened sometime at the latter end of May entirely destroyed them so that we have not one canker worm since that has been heard of."

The strange birds were not seen again, he added.

MORE PONDS BUT LESS WATER

Water is an important part of Ridgefield's geography. Rain that falls on the town can wind up in six watersheds and feed the drinking water supplies of New York City, Stamford, Norwalk and other southern Fairfield County communities. It can also wind up in the Norwalk or Housatonic Rivers.

Although many more ponds and lakes exist today than in 1700, there was once more water in Ridgefield.

We now have dozens of ponds and lakes, but early land and town meeting records mention only a few bodies of water that existed when the settlers arrived—Lake Mamanasco, Bennett's Pond, Round Pond and Little and Great Ponds.

Most of the original ponds were the remains of larger bodies of water formed in the troughs scraped out by glaciers and first filled by their melting ice twenty thousand years ago. Over the centuries, these lakes became smaller as the ice disappeared and runoff carried sand, silt and organic matter down the hills and gradually filled the basins. Lakes became ponds, ponds became swamps, swamps became moist meadows and finally, in places, dry land.

The Titicus River Valley along North Salem Road was once a long lake, the remnants of which are the river, swamps and Lake

Mamanasco. Lake Mamanasco was probably a dying pond in 1700 (in fact, it may have been two separate, dying "grassy" ponds, according to one translation of the Indian word *mamanasco*). When the settlers arrived, they built a dam at its outlet to raise the water level for a mill that stood at the end of Pond Road.

Round Pond on West Mountain is a different kind of glacial remnant—it's in a "kettle" (see page 145).

Though artificially created, the present Ridgefield Lakes may exist on territory that was water covered many centuries ago. What is now called Pierrepont Pond may long ago have been part of the large Titicus Valley lake, but it was mostly pasture land when Seth Low Pierrepont created the forty-acre pond in 1936.

Many ponds were created in the 1700s and early 1800s to store water for small mills, including New Pond, Upper Pond and Taylor's Pond that still exist. Many other millponds, however, have vanished because their dams were not maintained after the mills closed down.

A few small ponds were also created as sources of ice to harvest to fill the town's iceboxes. One existed across East Ridge Road from the middle school.

Some old ponds may have owed their existence to beavers, an animal that still shows up occasionally to create ponds in which to build a lodge. In early deeds for land near Silver Spring Swamp, there are several references to "ye beaver Damm" as a known locality.

In the twentieth century, many ponds have been created largely for decorative purposes. When they start turning green from algae and other blooms, they aren't so decorative, though.

THE MIGHTY MUGHTITICUS

While on the subject of water, consider the Titicus. Most people know there's a Titicus River in Ridgefield, and many know the Titicus Reservoir in North Salem, but they don't know what a "titicus" is.

Titicus is an abbreviated form of an ancient Indian word that has been in use for a river, a road, a hill and a neighborhood since the town's founding. The word has appeared in early records in many forms, including Mutighticus, Mughtiticoos, Mutighticoos, Mutighticoss, Matiticus, Metiticus, Tyticus and Titichus. It was in use in the New

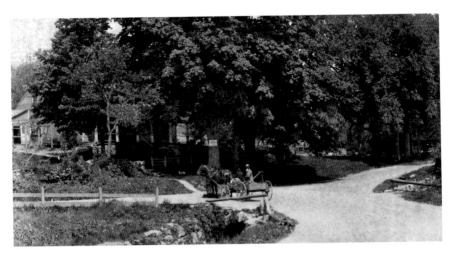

Aaron and Sarah Gilbert stopped at the watering trough at Titicus Crossroads, circa 1908. The river runs under North Salem Road in the foreground. The path to the left is Saw Mill Hill Road. *From the* Ridgefield Press *archives.*

York colony before Ridgefield was established, so its origin is probably in Westchester County, into which our river flows.

Attempting to explain the name, historian George L. Rockwell cited tradition, saying the "Mutighticoos River was at one time called Buffalo Creek. Van der Donck, a historian of Yonkers, writing in 1656, says: 'Buffalos are also tolerably plenty.'" From this, Rockwell suggests that Mutighticoos meant buffalo.

However, in his *Indian Place Names of New England,* John C. Huden translates both *Mutighticoss* and *Titicus* as Mahican or Algonquian for "place without trees." George R. Stewart's classic, *American Place Names,* offers a similar translation: "without-trees-at." This, not buffalo, is probably the meaning, referring to a section of the river that flowed through an open plain.

Needless to say, Mutighticoss in its sundry forms is a mouthful; thus, it's no surprise that the English settlers, unaccustomed to the native tongue, tended to shorten the words like this, with the end result in this case, Titicus. (It's surprising that Mamanasco, a word that to this day can twist local tongues, remained unchanged.)

Titicus was first associated by the settlers with the river and then with the territory around it—Titicus Swamp, Titicus Hill, Titicus

Mountain, Titicus Plain, Titicus Road, etc. Eventually, the area around the intersection of North Salem, Saw Mill Hill and Mapleshade Roads became known as "Titicus" or sometimes "Titicus Crossroads." This area was once a small village with a store, post office (having its own cancellation—see page 102), schoolhouse (now the American Legion Post), several mills and small factories and a large cemetery.

No discussion of Titicus would be complete without the story of Duncan Smith's challenge. One day in the 1940s, a group of *Ridgefield Press* staffers was talking about words that had no rhymes—like orange. Someone mentioned Titicus, and Mr. Smith, a retired columnist with the *Chicago Daily News* who lived in Ridgefield, took up the challenge. He offered the following in his *Press* column called "A Birdseye View":

> *I live upon the Titicus,*
> *a river rough and raging,*
> *where fishes to a city cuss,*
> *will come for a simple paging.*
> *I used to read Leviticus,*
> *or some such ancient volume,*
> *before I saw the Titicus*
> *or started on this column.*
> *And now, my dears, you might agree*
> *it really takes a witty cuss,*
> *a crossword puzzler (that's me)*
> *to rhyme with Titicus.*
> *(It really should have said 'that's I'*
> *to show for words I have nice sense,*
> *but for such slips, I alibi*
> *with my poetic license.)*

DRINKING FROM A GIANT KETTLE

Round Pond, one of the few natural bodies of water in Ridgefield, is, at thirty-two acres, the second largest. At 778 feet above sea level, it is also the highest. But that's not what makes it unusual.

Round Pond is so called because it is rather round in shape. That roundness comes from the geologic formation that created it—a kind of

"fluvioglacial landform," as glaciologists would put it: Round Pond fills a "kettle."

Kettles were created when a glacier receded, leaving occasional large, isolated masses of buried ice. As the ice gradually melted and the ground above it slowly sank, a bowl-like depression formed. On West Mountain, a spring or springs and a relatively small watershed have filled the bowl with water to create Round Pond.

The pond had its name at least by 1721, when it was mentioned in the settlers' third purchase from the Indians. Its early uses included a source of stored water for at least one sawmill and as a place to fish. Apparently, however, by 1817, the pond was being fished out. In Ridgefield's first recorded effort at conservation, the town meeting that spring voted "that no person or persons shall draw any sein or seins, use or employ any hook, pot, or other implement by which fish are or may be caught or taken, in the Round Pond, so called…for the term of two years from and after the 1st day of April, AD 1817, under penalty of $10 for every fish so taken or caught." A year later, the fishing ban was extended indefinitely.

Early in the twentieth century, the pond was one of several used as a source of ice for the community's iceboxes, the predecessor of the refrigerator. An icehouse existed on its shore as late as 1927.

It was about 1900 when the pure water of this spring-fed pond became a reservoir for the Ridgefield Water Supply Company. At that time, virtually no houses stood in its watershed. Today, there are some, most of them built in the Eight Lakes subdivision. In the 1990s, Aquarion, which bought Ridgefield Water Supply Company, stopped using it as a reservoir because it would be too expensive to build a purification plant that new federal regulations required. Instead, Aquarion piped water to town from the Saugatuck, Aspetuck and Hemlock Reservoirs. (The Saugatuck is fed with waters from the Limestone and Bennett's Farm sections of Ridgefield.)

In October 2004, Round Pond became state property, part of the "Centennial Watershed State Forest" that includes fifteen thousand acres the state acquired from Aquarion, largely in other counties.

Incidentally, at the turn of the century, someone tried to take the Round out of the Pond, renaming it "Lake Oreneca," apparently feeling "Round" lacked class. Fortunately, the effort didn't succeed, and Ridgefielders stuck to the age-old name. There has also been no luck for those who would call it "Round Lake." At thirty-two acres, a "lake" it's not.

THE SILVERY SPRING

Silver Spring is one of the oldest surviving place names in Ridgefield, first mentioned as "ye Silver Spring" in a 1722 town record describing a highway being laid out (probably Silver Spring Road). It's a sign of the name's popularity—perhaps due to its attractiveness—that it has survived so long.

Certainly, the spring itself is no massive landmark. Situated on a quarter acre of wooded, town-owned land on the east side of Silver Spring Road, about two thousand feet north of Saint Johns Road, the spring emerges in several spots, mostly covered with boulders—apparently put there as protection. There is a small, sandy-bottomed pool where Ridgefielders for more three centuries watered their horses, livestock or themselves. For generations people have collected the water in bottles to use at home, a practice that has probably declined because of the influx of runoff from the neighborhood and the nearby golf course that may make the water somewhat less than pure.

The Reverend S.G. Goodrich wrote in 1800 that Silver Spring was "most remarkable…The water is very cold and heavy. It discharges about one-fourth water sufficient to carry a grist mill and is not materially affected by freshet (i.e., flood) or drought."

It is the crystal-like clarity that probably led to the naming of the spring. As old-timer John Mullen (1898–1985) said in a 1975 interview, "You look down and watch the water coming up. It looks like silver."

Most Silver Springs around the country have been named for the appearance of the water, not for the metal, which may or may not be found nearby. At least fourteen states have places called Silver Spring or Silver Springs.

The spring has not always led a peaceful existence. "Should the town's famed Silver Spring be cleaned up and modernized or should it be left as the early settlers fixed it up when they discovered its bubbling water more than 200 years ago?" began a front-page story in the December 22, 1954 *Ridgefield Press*. First Selectman Harry E. Hull had proposed the face-lift "in the interest of greater utility…Several times a year the selectmen have the town crew clean out the muck and leaves around the spring and this year, Mr. Hull had them put in a tile so the water would run off and the spring would stay cleaner. This is the part of the improvement plan which stirred the objection of neighbors." The neighbors eventually won out, and the spring remained untouched.

Back in 1931, the Flat Rock Corporation, which was then building the Silver Spring Country Club across the road, asked the town for permission to draw from the spring in perpetuity for drinking water. A town meeting rejected the idea after strenuous opposition from the public.

Later, two Silver Spring neighbors, both of whose cattle drank from the spring, became involved in one of those old-time feuds over its use, leading on one occasion to police intervention and eventually a lawsuit. "Its water," the 1954 *Press* said, "is reputed to have medicinal qualities. It is a fact that its waters are clear and cold." Apparently, one of the medicinal effects wasn't calming the soul.

However, in 2014, there's been a new and calming addition to the spring: someone has placed a park bench alongside it, for a more comfortable and relaxing view of those silvery waters.

BIBLIOGRAPHY

Ables, Kay, et al. *A View from the Inn: The Journal of Anna Marie Resseguie, 1851–1867*. Ridgefield, CT: Keeler Tavern Preservation Society, Inc., 1993.

Bailey, James Montgomery. *History of Danbury, Connecticut, 1684–1896*. New York: Burr Printing House, 1896.

Bedini, Silvio A. *Ridgefield in Review*. Ridgefield, CT: 250th Anniversary Committee, 1958.

Cornwall, L. Peter. *In the Shore Line's Shadow: The Six Lives of the Danbury & Norwalk Railroad*. Littleton, MA: Flying Yankee Enterprises, 1987.

Goodrich, Samuel G. *Recollections of a Lifetime*. New York: Miller, Orton and Mulligan, 1856.

Haight, Robert S. *St. Stephen's Church, Ridgefield, Connecticut, Its History for 250 Years*. Ridgefield, CT, 1975.

Huden, John C. *Indian Place Names of New England*. New York: Museum of the American Indian Heye Foundation, 1962.

Hurd, D. Hamilton. *History of Fairfield County*. Philadelphia: J.W. Lewis & Co., 1881.

Jones, Keith Marshall, III. *The Farms of Farmingville*, Ridgefield: Connecticut Colonel Press, 2001.

Jordan, Alvin R., et al. *A History of the Town of Lewisboro*. South Salem, NY: Lewisboro History Book Committee, 1981.

Land Records and Vital Records. Town of Ridgefield, 1708–1900.

Martin, James Kirby. *Benedict Arnold, Revolutionary Hero: An American Warrior Reconsidered*. New York: New York University Press, 1997.

Nash, Jared. *Diary, 1865–66*. Edited by Jack Sanders. RidgefieldHistory. com.

Ridgefield Archives Committee. *Images of America: Ridgefield*. Charleston, SC: Arcadia Publishing, 1999.

Ridgefield Press, 1875–2006.

Rockwell, George L. *The History of Ridgefield, Connecticut*, Ridgefield, CT: privately printed by the author, 1927.

Sanders, Jack. *Five Village Walks*. 3rd edition. Ridgefield, CT: Ridgefield Historical Society, 2008.

———. *Notable Ridgefielders*. Ridgefield, CT: Ridgefield Press, 2000.

———. *Ridgefield Names*. Ridgefield, CT: RidgefieldHistory.com, 1995.

———. *Ridgefield, 1900–1950*. Postcard History Series. Charleston, SC: Arcadia Publishing, 2003.

Stewart, George R. *American Place Names*. New York: Oxford University Press, 1970.

Teller, Daniel W. *The History of Ridgefield, Connecticut*. Danbury, CT: T. Donovan, 1878.

Thompson, Wilbur F. *Georgetown*. Edited by Irene Baldwin. Redding, PA: privately published, 1965.

Welsh, Glenna M. *The Proprietors of Ridgefield*. Ridgefield, CT: Caudatowa Press, 1976.

INDEX

Y